CONE OF SHAME

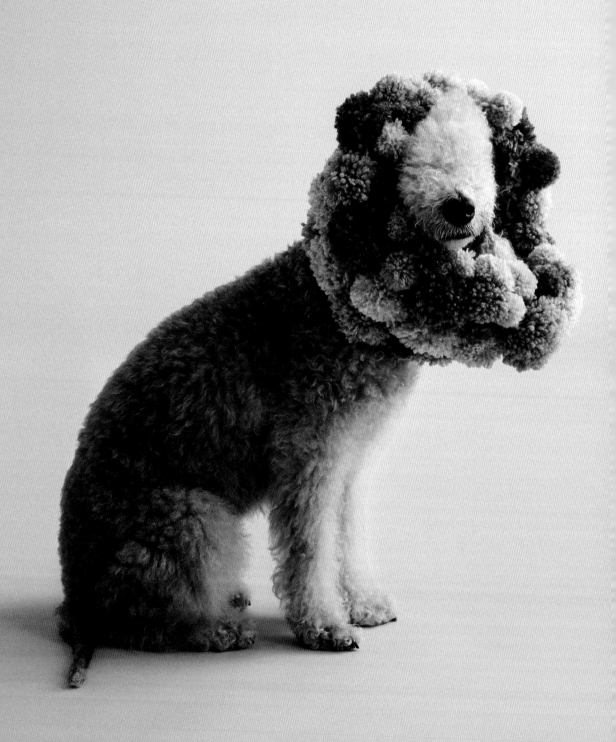

WINNIE AU

CONE OF SHAME

DESIGNS BY MARIE-YAN MORVAN

UNION
SQUARE
& CO.

NEW YORK

INTRODUCTION

Tartine was the first dog my now-husband, Florent, and I had together. She was a beautiful, sweet corgi, a fluffy piece of heaven. We were obsessed. We followed a blog called *OCD: Obsessive Corgi Disorder*. I found a niche Japanese magazine called *Corgi Style* that I fawned over. Florent named one of his video game usernames after her. I started a blog comparing Tartine to my meals. Corgi-shaped mugs entered our home. Our friends would forward us videos with titles like "Corgi Flop" and "Corgi Rae Jepsen."

Tartine loved all humans, and she would immediately flop on her back when you saw her, begging for a belly rub. She contorted her body in all sorts of funny ways, as corgis often do, and I spent my days photographing her amusing body positions. Our crowning achievement was having her named as one of BuzzFeed's "Most Important Corgis of the Year." Yes, that's a list you can get on, and we were pleased as punch to revel in Tartine's five minutes of internet fame.

If you picked up this book, my guess is that you love dogs, and you're slightly obsessed with your own dog. Maybe your dog has more beds than you do. Maybe your dog sleeps in your bed. Maybe you've rearranged all of your travel plans just to make sure your dog could come with you. Maybe you don't have a dog (yet), and you keep finding yourself wistfully hanging out near dog parks. In whatever ways

it manifests itself, our love for dogs is something unmistakable.

You probably also understand the way our hearts sank and broke in a million pieces when Tartine got sick. She was the perfect dog, had never had an accident inside, but one day, she did. She had a small little cough that we assumed/hoped was just kennel cough, but a few tests revealed what we really didn't want to hear: she had throat cancer. After much deliberation, we decided to move forward with a combination of radiation and chemotherapy. The doctors said that, if the treatments were successful, it could lengthen her life and time with us. We were desperate and willing to try anything.

In the end, after a month of never-ending hospital visits and treatments, after cooking all her meals and spoon-feeding her, she just seemed to be having more bad days than good ones. She eventually wasn't able to eat at all, and she was suffering. We decided to put her to sleep, and it was one of the hardest things we've ever had to go through. We were heartbroken. We missed the little clicking of her paws on the ground, we missed our daily walks, and we had no idea what to do with her bed, her bowls, all of her cute corgi things.

Tartine is resting peacefully now, and of course we still miss her. Months later, we fostered and then adopted a wonderful basset hound named Clementine. Florent was

insistent that he did not want another dog, that it would be too painful. But once Clementine came into our lives, both of our hearts melted all over again. She is a sweet rescue (with a few quirks!) who used to be a puppy mill mom, and you will get to meet her soon. She has a little cameo in this book.

The whole experience with Tartine made me acutely aware of the crazy cost of medical bills, especially unexpected ones, for pets. We were lucky at the time and had pet insurance that covered most of our costs. It was one of the reasons we moved forward with the chemotherapy and radiation treatments. But I realized that when your dog is sick or injured, it's horrible to have to make medical decisions based on finances. So I vowed to do something about it. I decided to find a way to help raise funds for dogs with urgent medical needs, using what I know best—photography.

In the years since Tartine's passing in 2017, I've been photographing dogs wearing cones. These aren't your everyday cones of shame. These are artfully designed custom collars created by designer Marie-Yan Morvan. Each dog, cone, and backdrop has been conceived as a mash-up of abstract shapes, tones, and textures. With this series, I wanted to take that post-surgery humiliation—that saddest moment for every pet—and twist it into something beautiful and majestic. I wanted to take the shame out of the cone.

The goal of the Cone of Shame series is to help raise awareness for rescue dogs who have urgent medical needs. Since I began the series, a portion of any proceeds I've made has been donated to Animal Haven's Recovery Road Fund. It's been a cathartic process and has helped me channel some of the pain I felt from the loss of Tartine into something positive and fulfilling.

I hope that as you flip through these pages, these images bring you as much joy as I felt creating them. Your purchase of this book will not only celebrate the love we have for our furry companions, but also play a part in helping animals in need. Thank you for your support and for joining me on this meaningful journey.

This one is for the dogs. *Cone of Shame* is dedicated to Tartine, who taught us how to be selfless and joyful. Thank you for completing our family.

xo,
Winnie

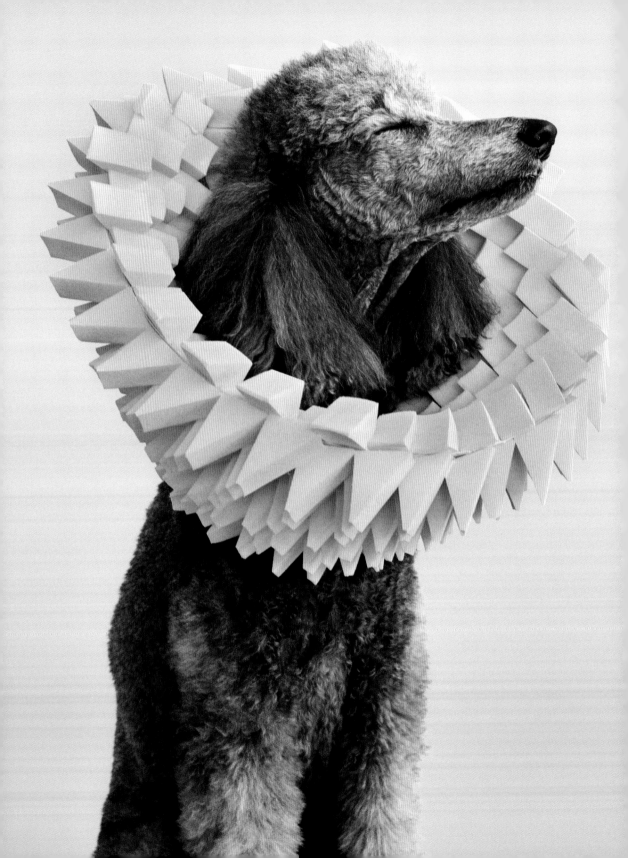

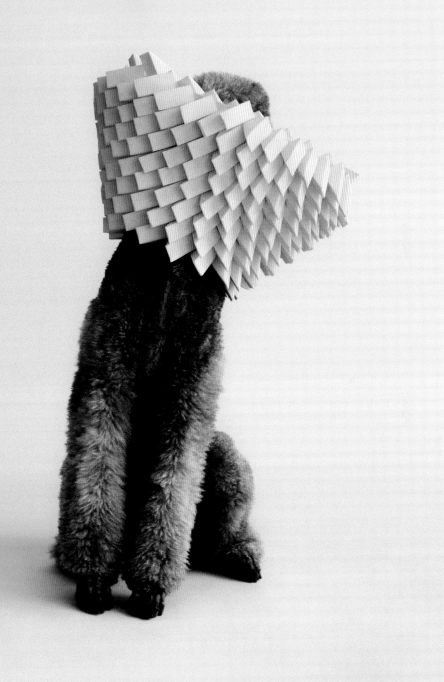

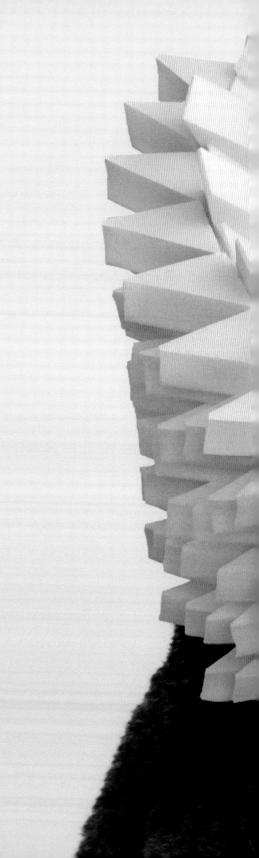

Jolie
Standard Poodle, 10 years old
Painted makeup sponges on plastic base

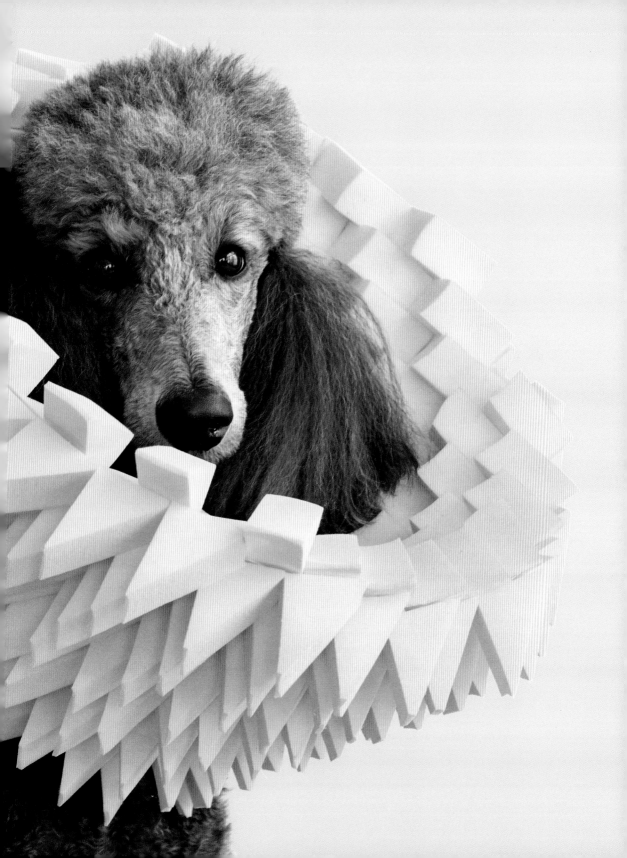

Ryder

Old English Sheepdog, 7 years old

Batting and pigments on plastic base

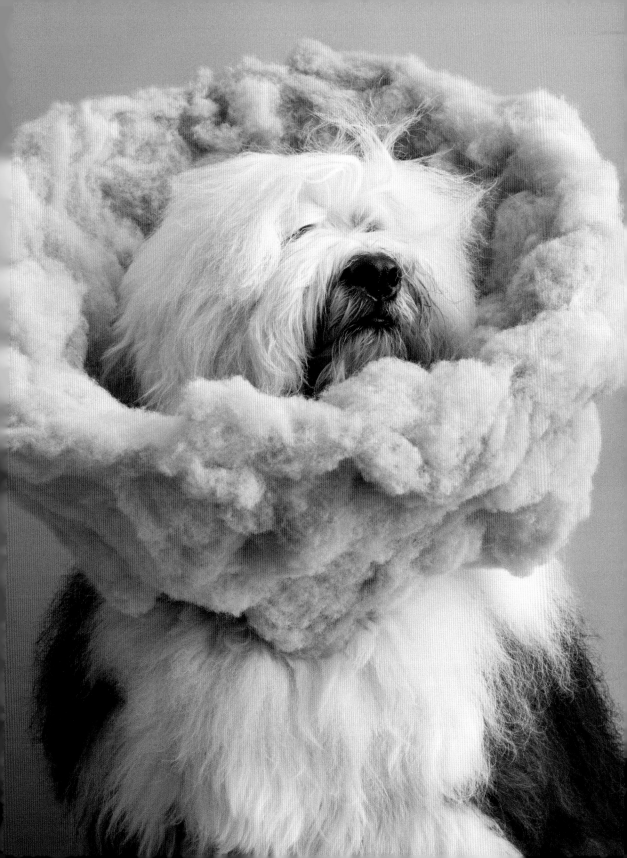

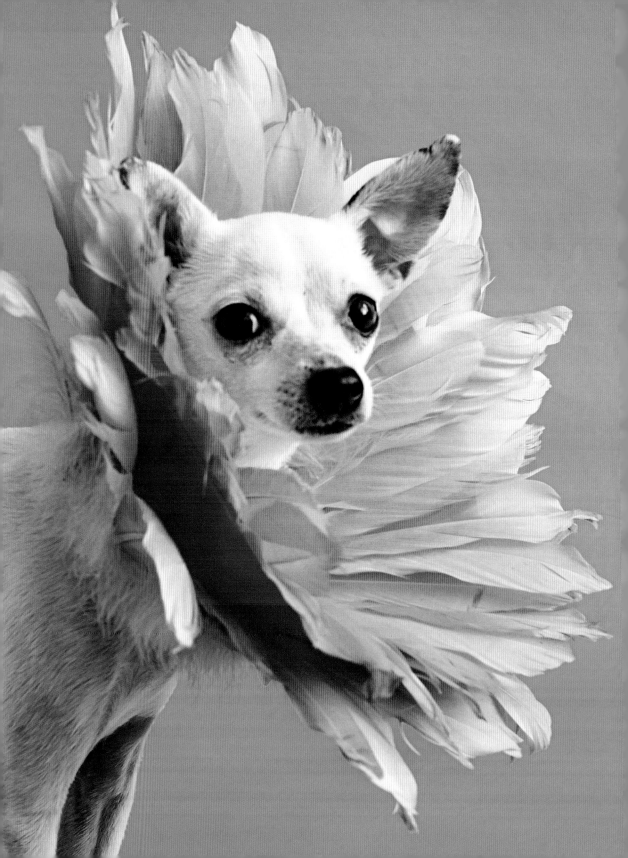

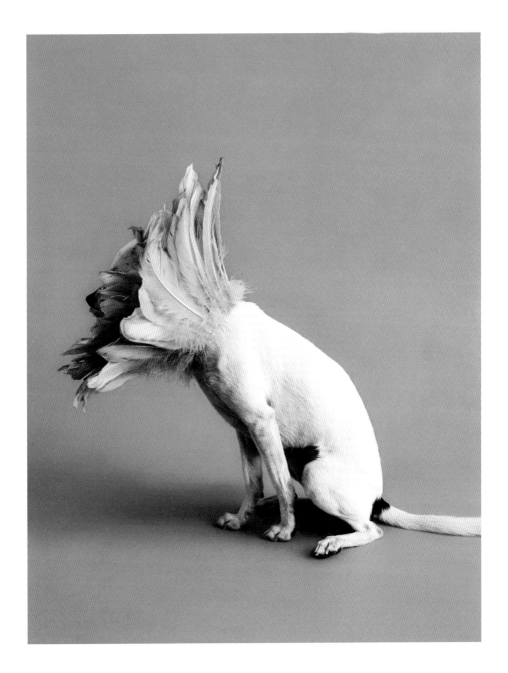

Agnes
Chihuahua-Whippet Mix, age unknown
Feathers and pink dye on plastic base

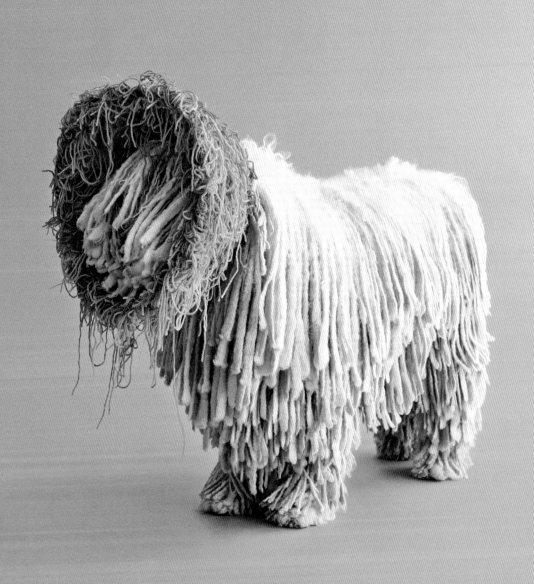

Calvin
Komondor, 8 years old
Wool yarn on plastic base

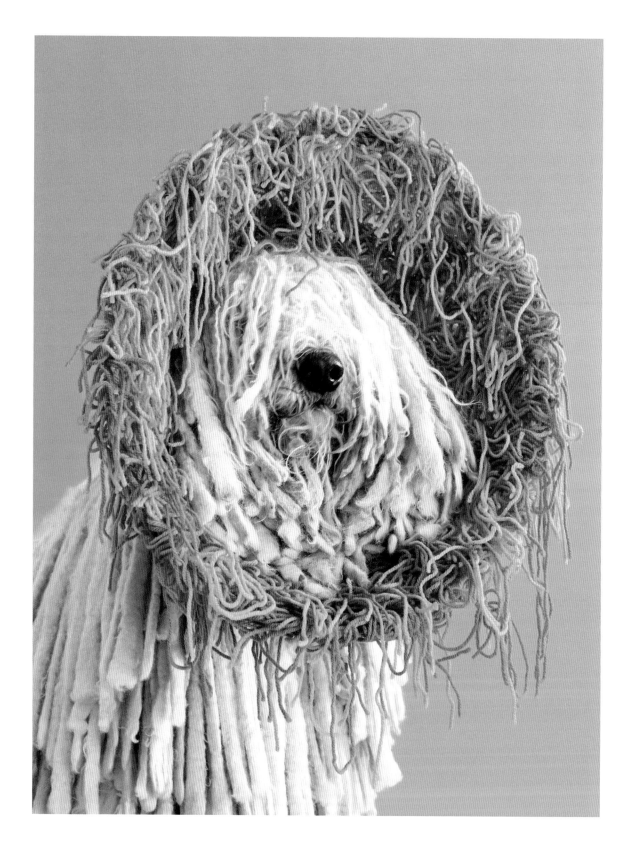

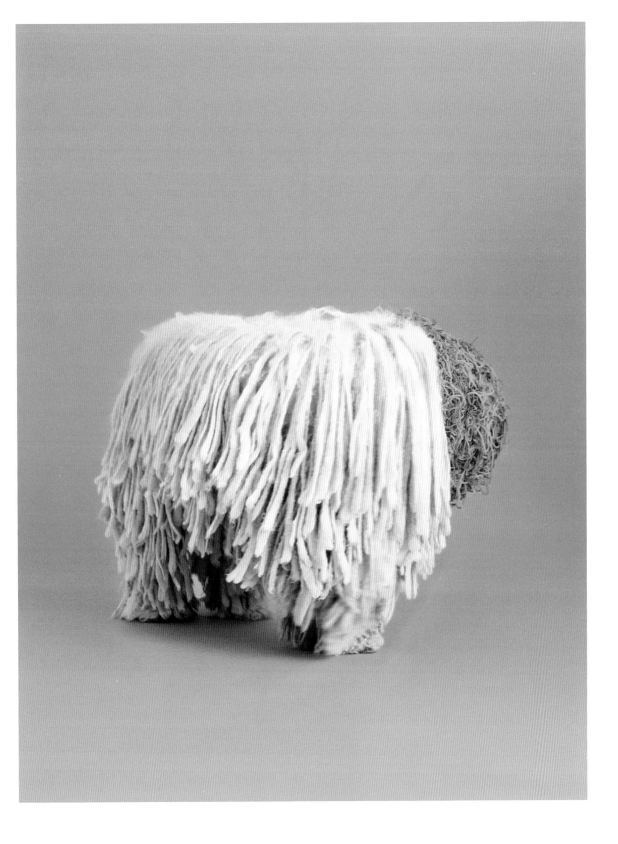

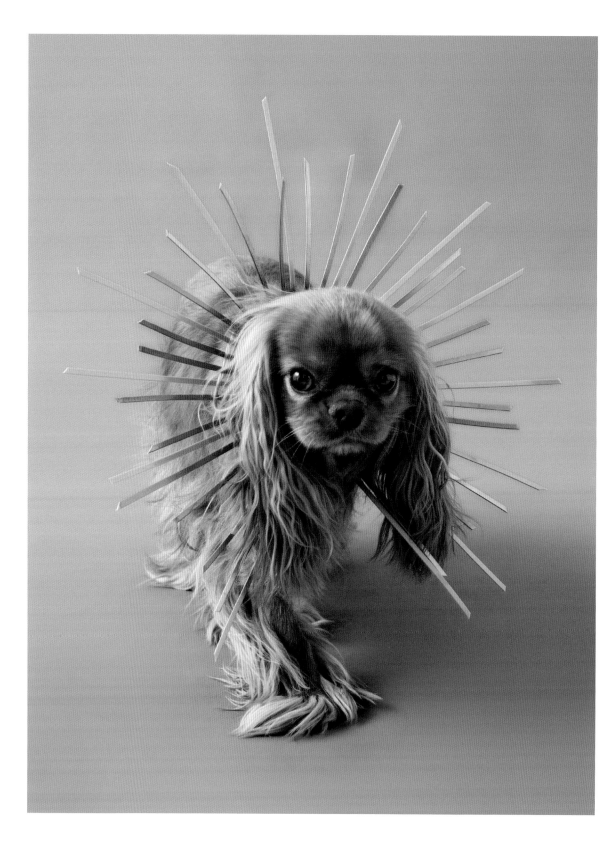

Lumi
Cavalier King Charles Spaniel, 5 years old
Zip ties and acrylic paint on brown collar

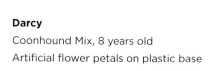

Darcy

Coonhound Mix, 8 years old

Artificial flower petals on plastic base

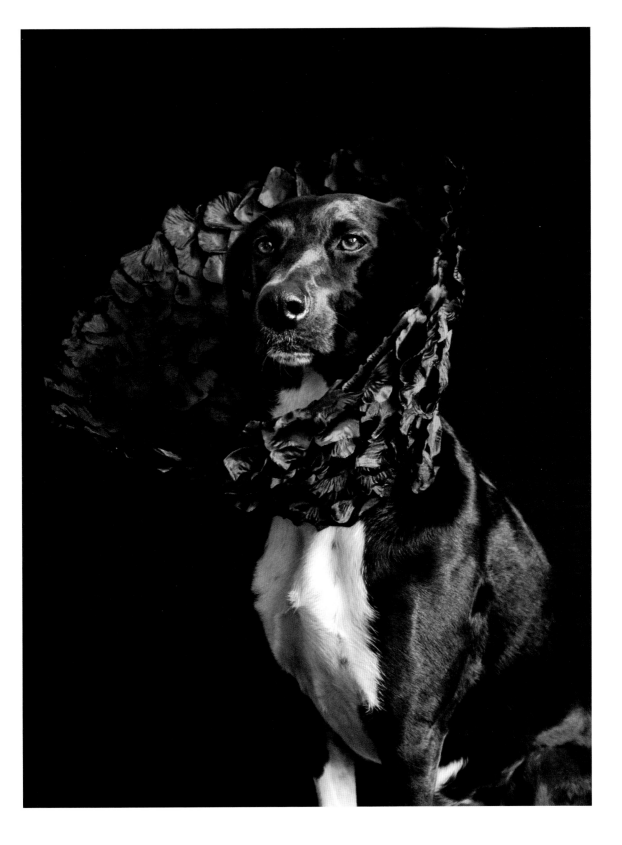

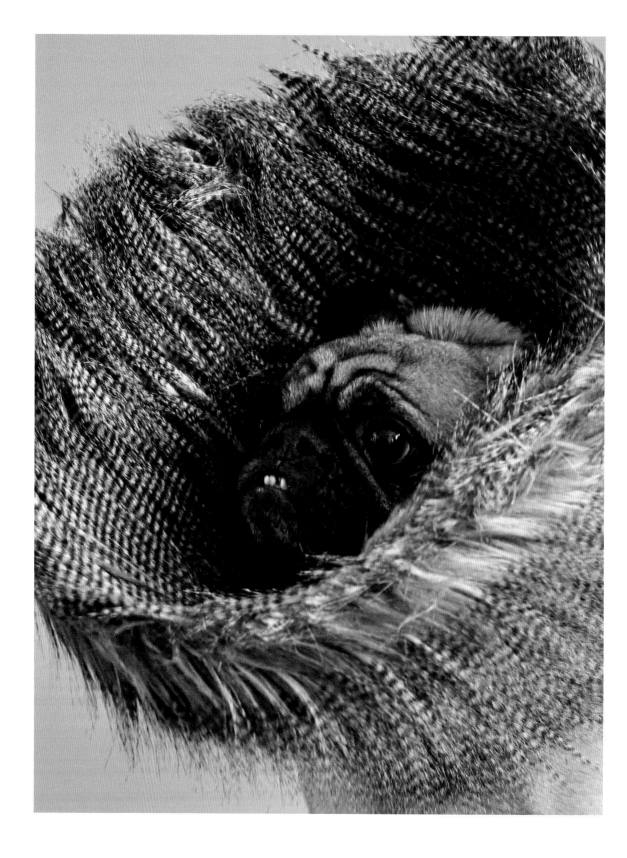

Bitters
Pug, 11 years old
Faux fur

Hank

Wolfhound-Sheepdog Mix, 7 years old

Live pothos plant, artificial string of pearls plant

on polystyrene foam ring

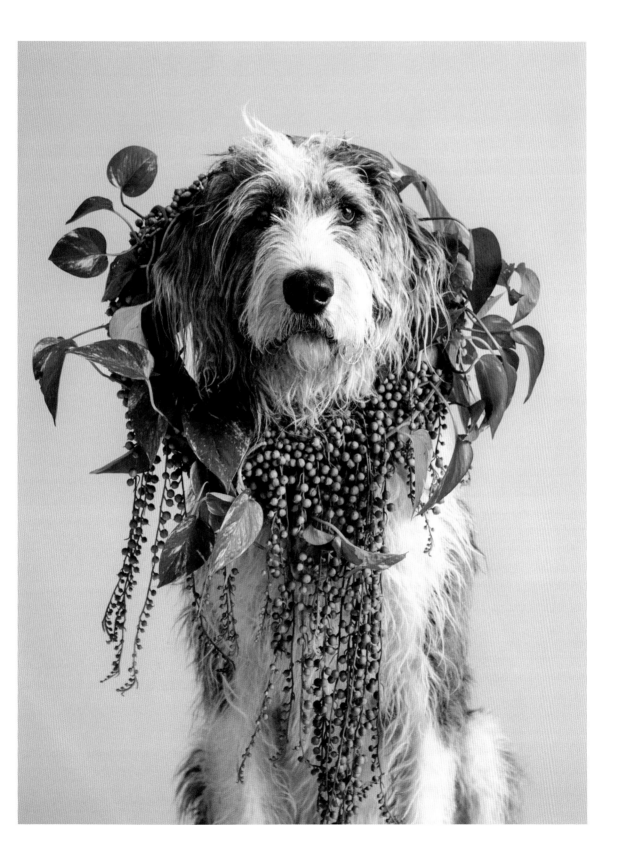

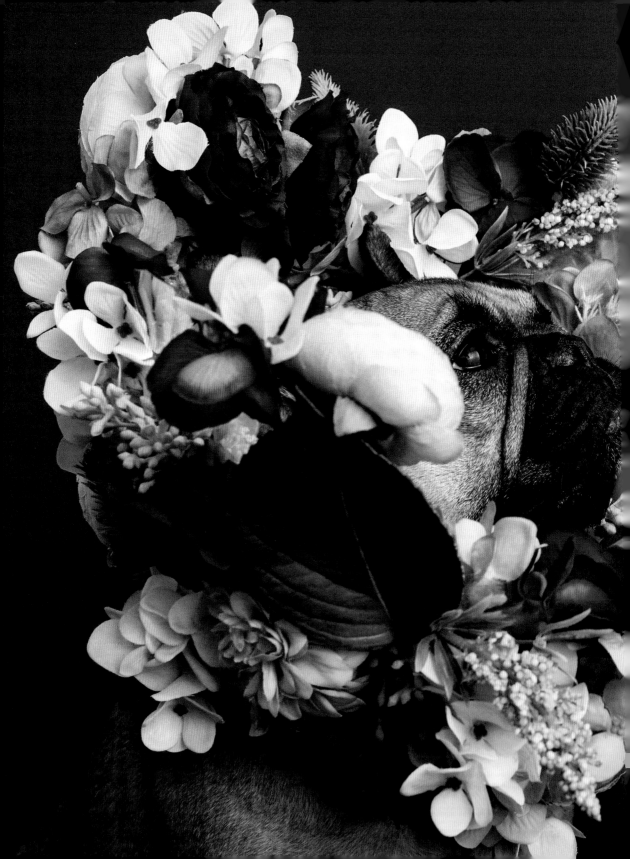

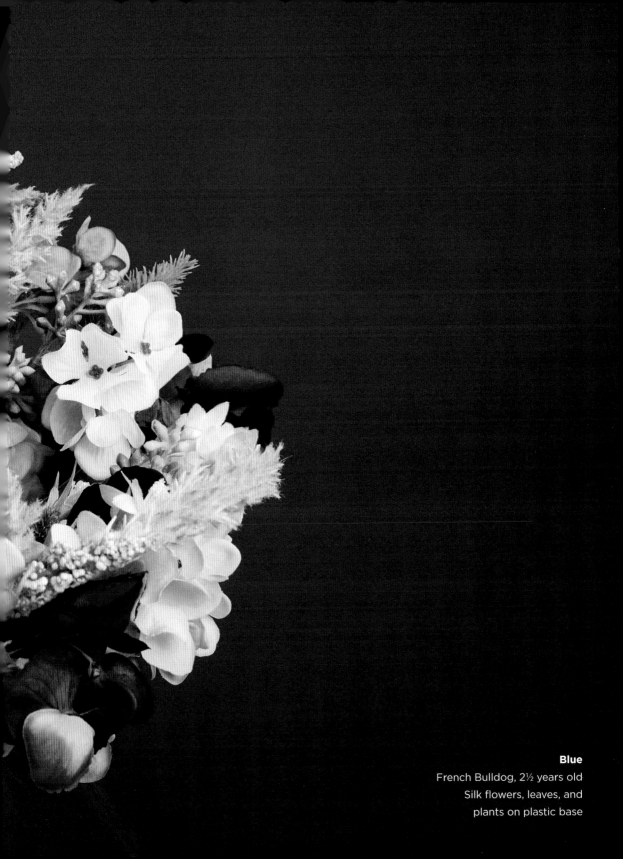

Blue
French Bulldog, 2½ years old
Silk flowers, leaves, and
plants on plastic base

Andele
Lakeland Terrier, 1½ years old
Preserved moss on plastic base

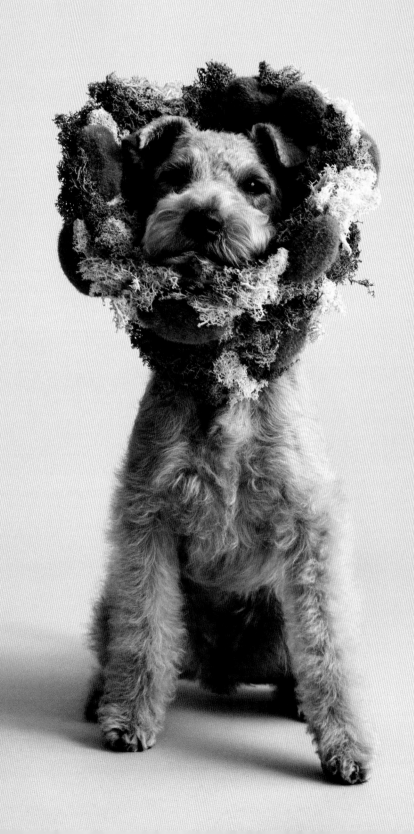

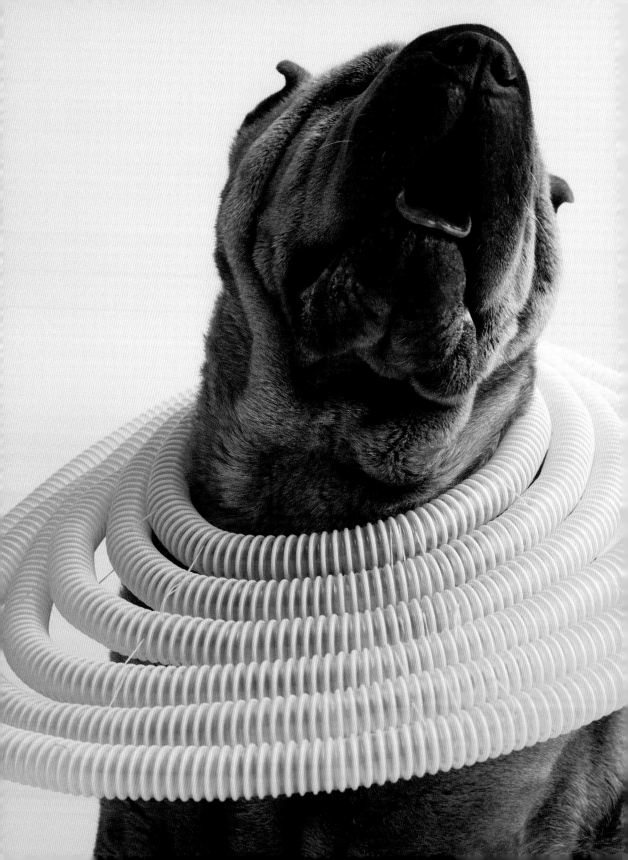

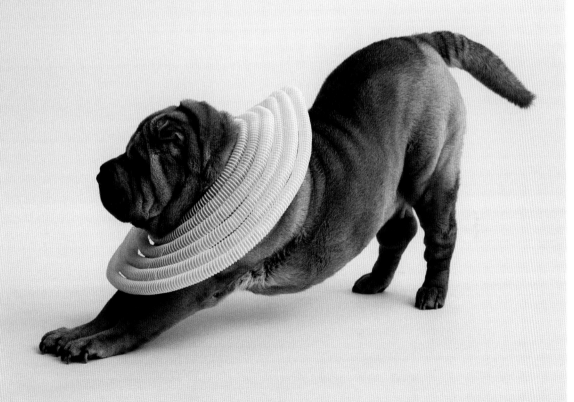

Tia
Chinese Shar-Pei, 11½ years old
Surgical tubing

Waldo

Bedlington Terrier, 5 years old

Custom wool pom-poms on plastic base

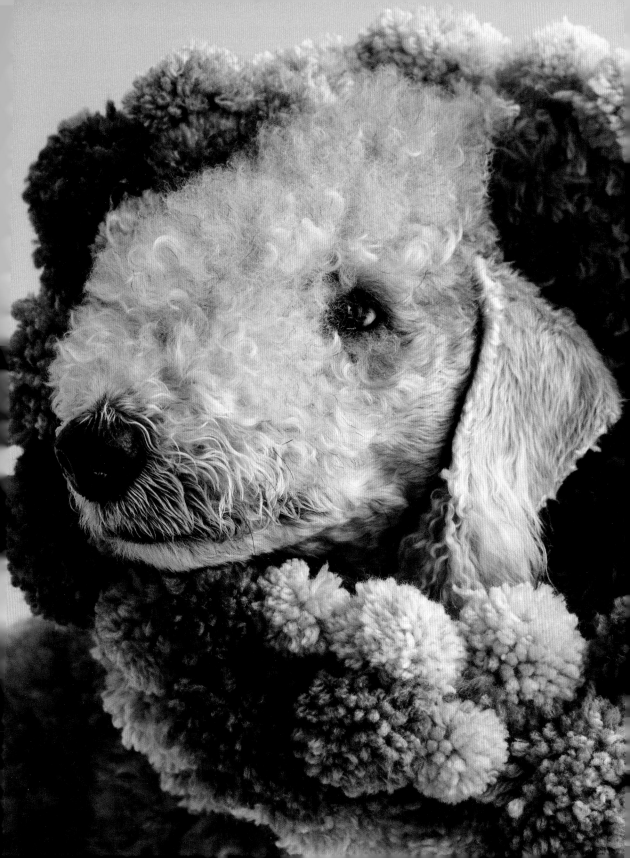

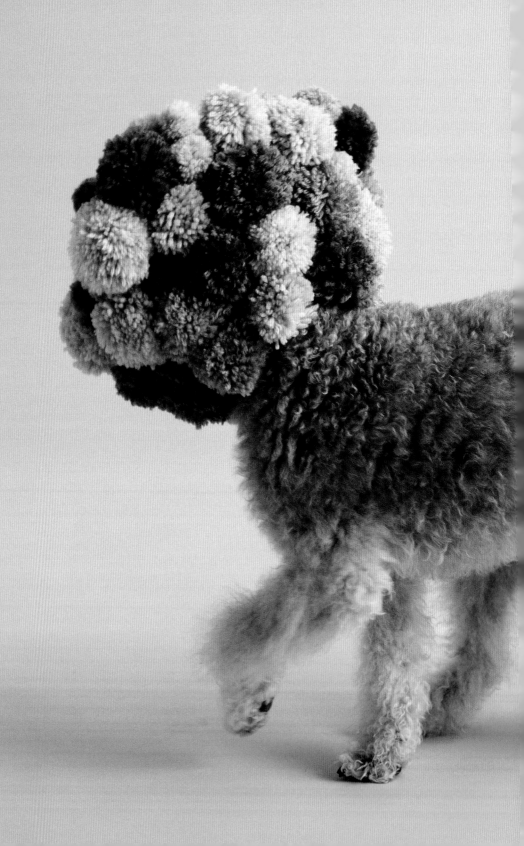

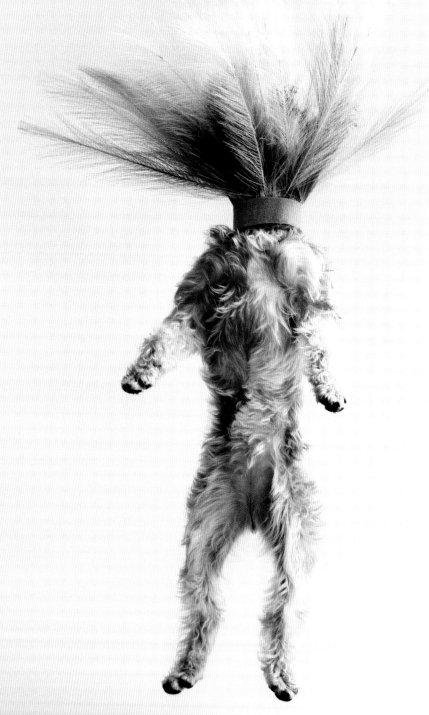

Olive
Miniature Schnauzer, 2 years old
Faux pampas grass on gray felt collar

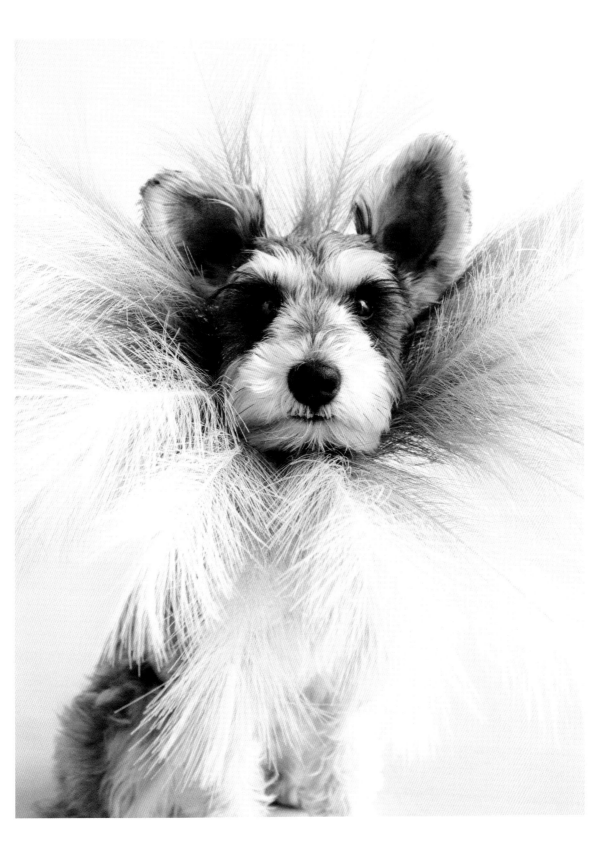

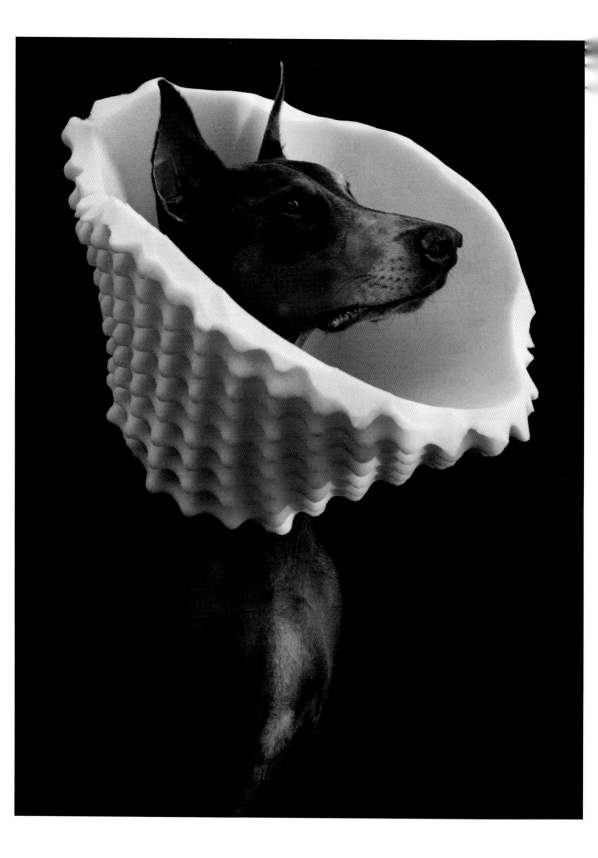

Zissou
Doberman Pinscher, 3 years old
Convoluted antistatic foam

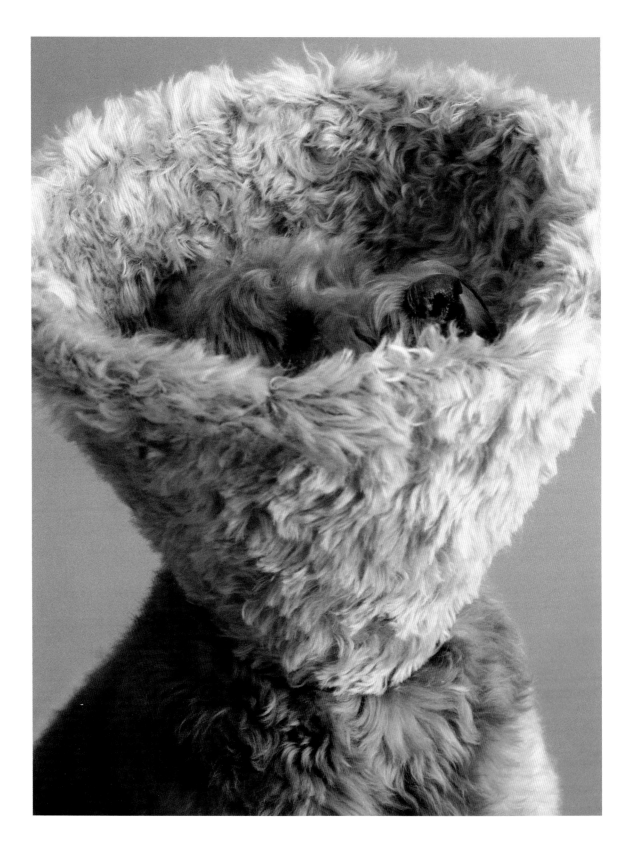

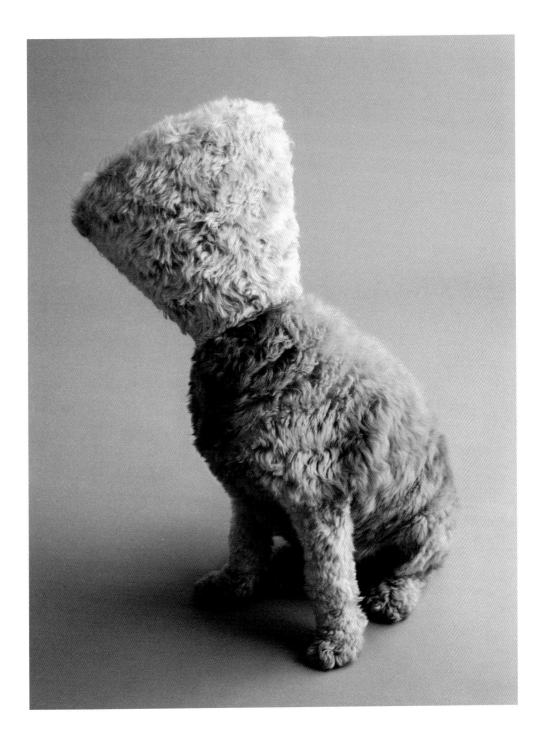

George
Goldendoodle, 3½ years old
Faux fur on plastic base

Quincy Fox

Pomeranian, age unknown

Velvet paper

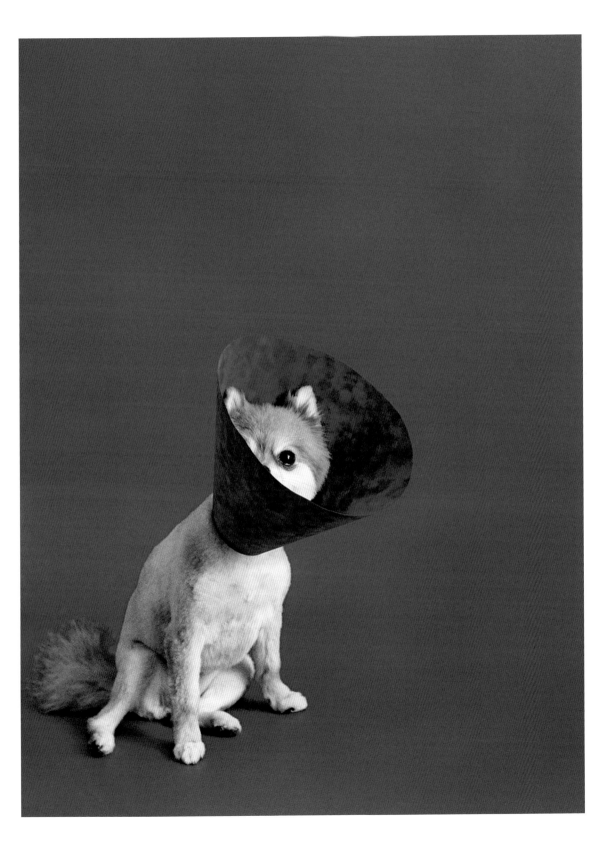

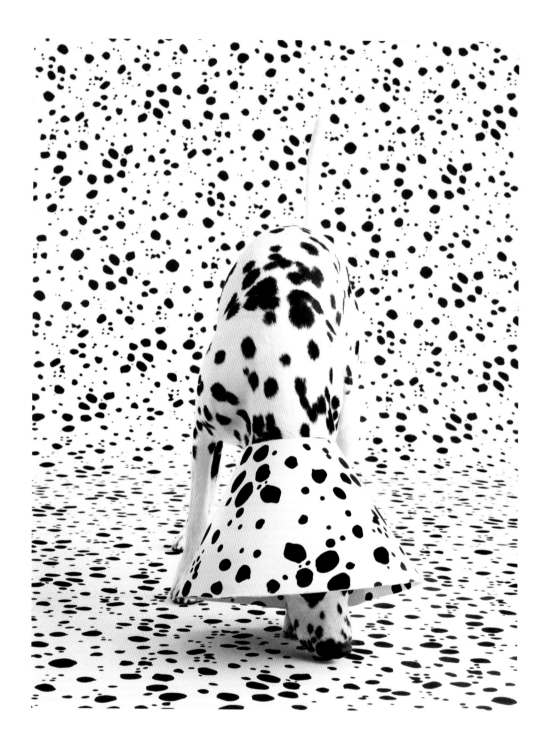

Patch
Dalmatian, 1½ years old
Fabric on paper base

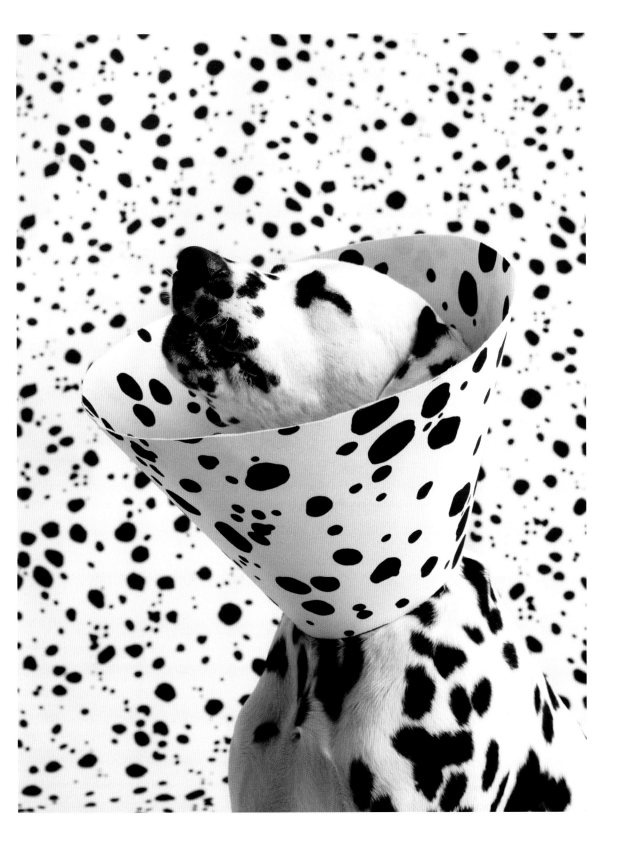

Frankie
Hound-Lab Mix, 11½ years old
Folded paper

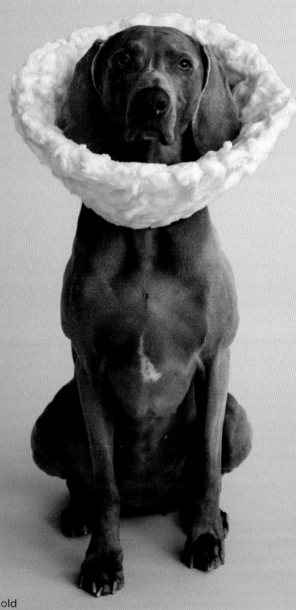

Kyrie
Weimaraner, 9 years old
Natural cotton on paper base

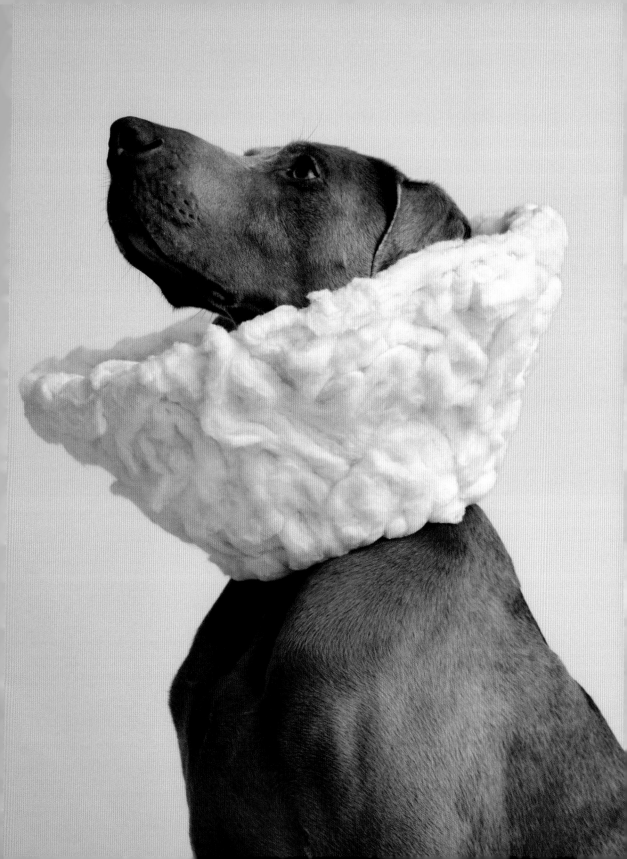

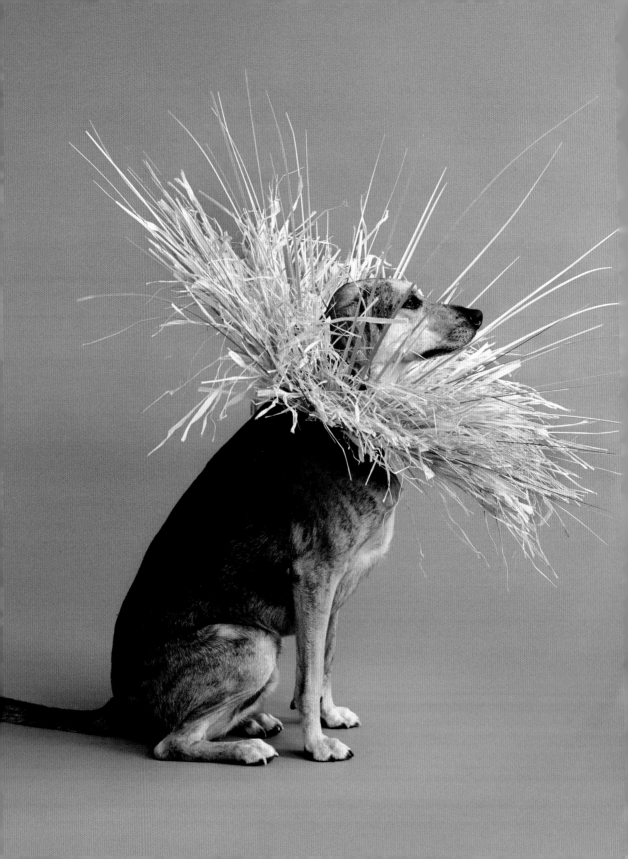

Milo
Hound Mix, 7 years old
Straw on plastic base

Tyler
Chow Chow, 2 years old
Faux fur on plastic base

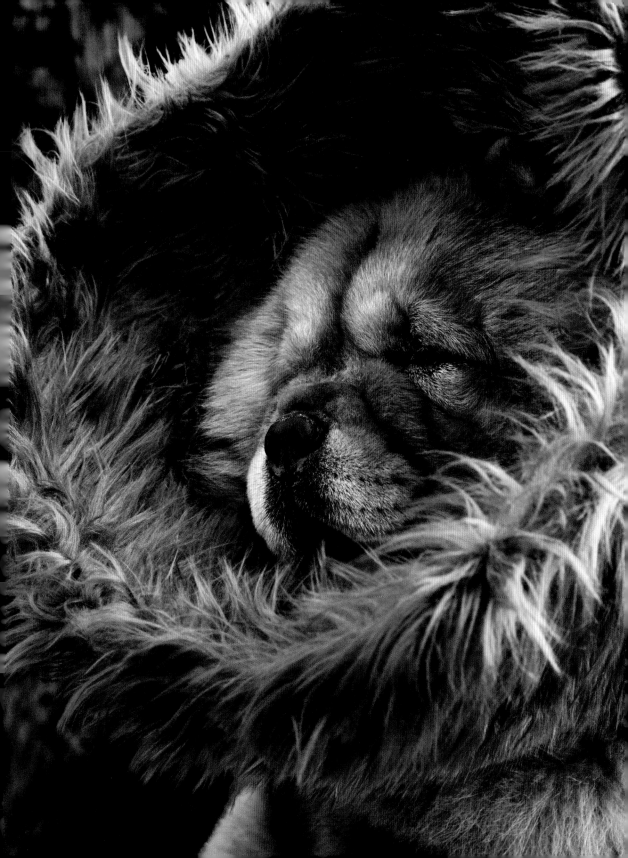

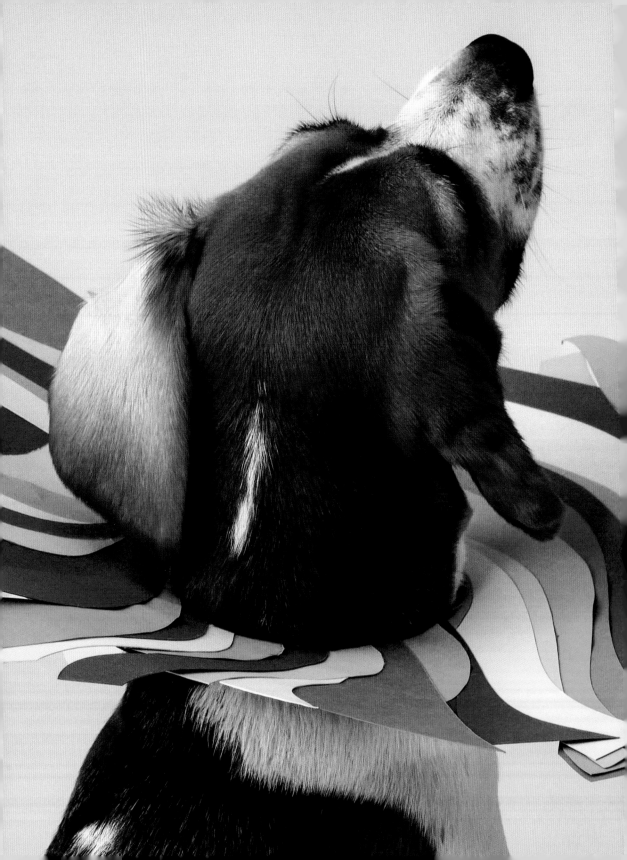

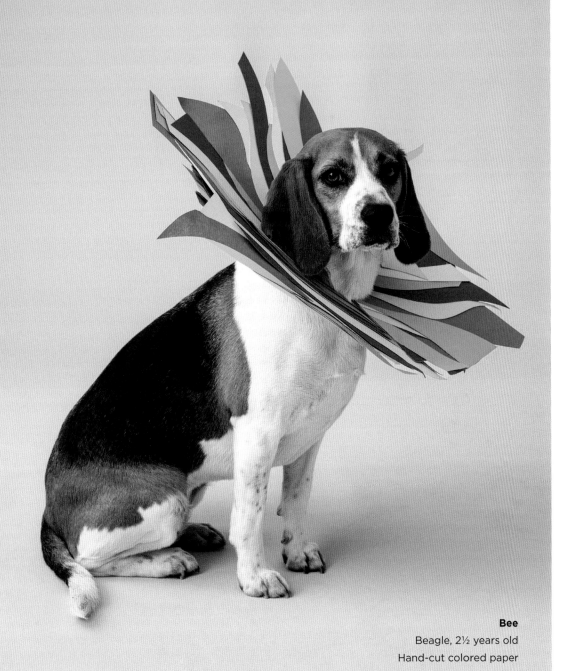

Bee
Beagle, 2½ years old
Hand-cut colored paper

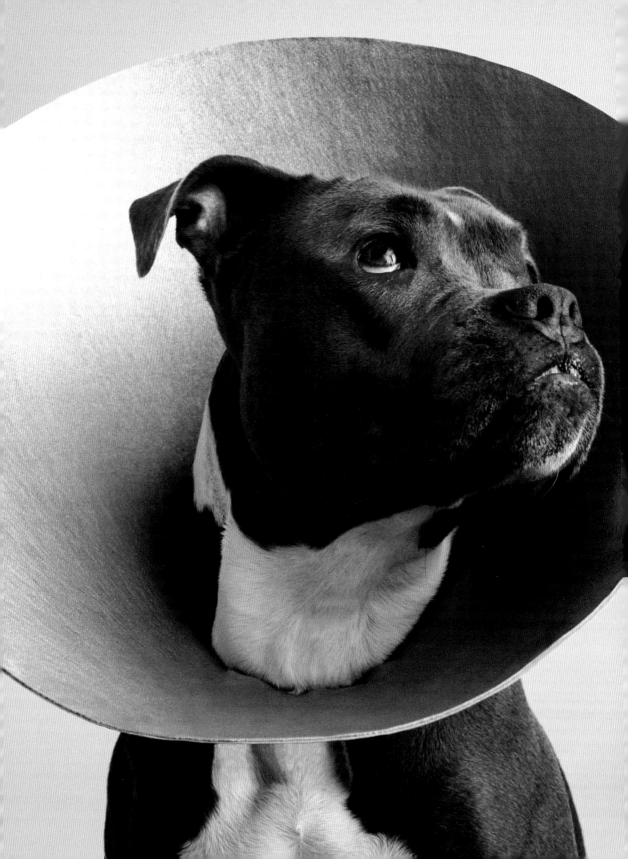

Lux
American Staffordshire Terrier, 9 years old
Gold paper

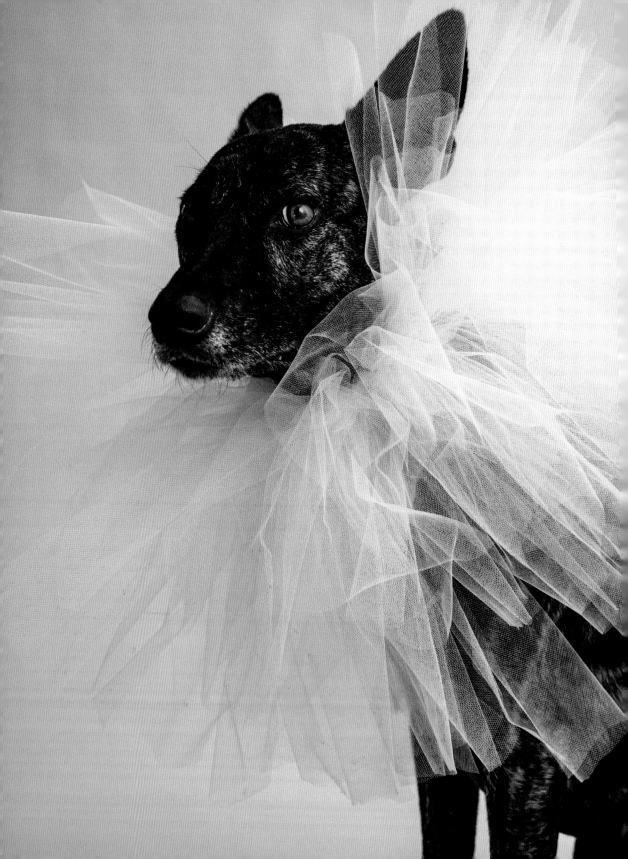

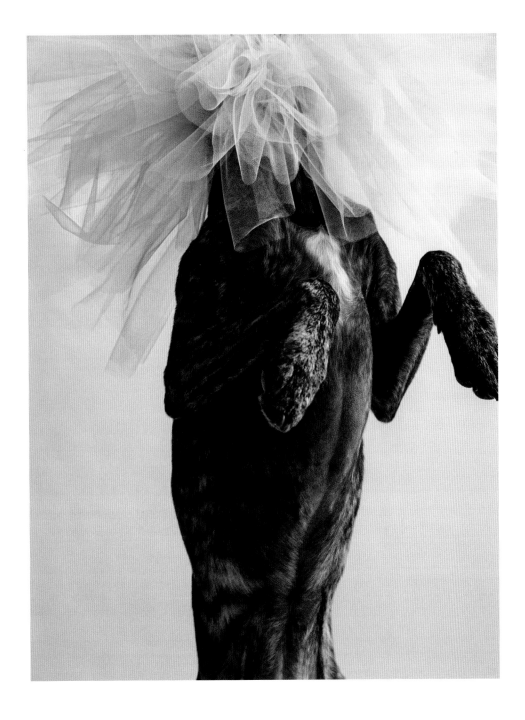

Echo
Mutt, 5 years old
Tulle fabric

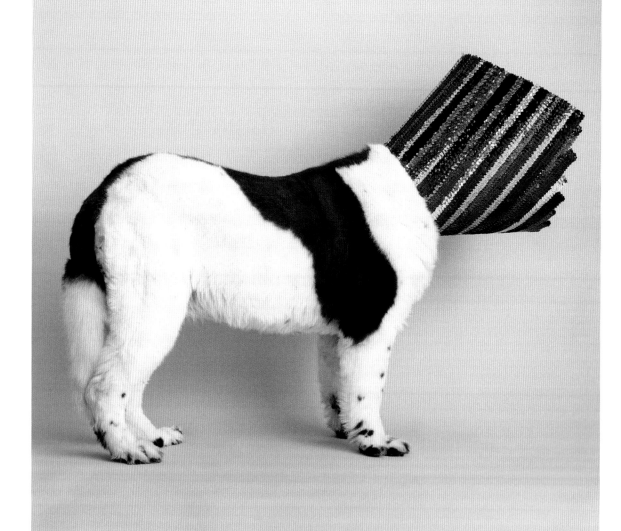

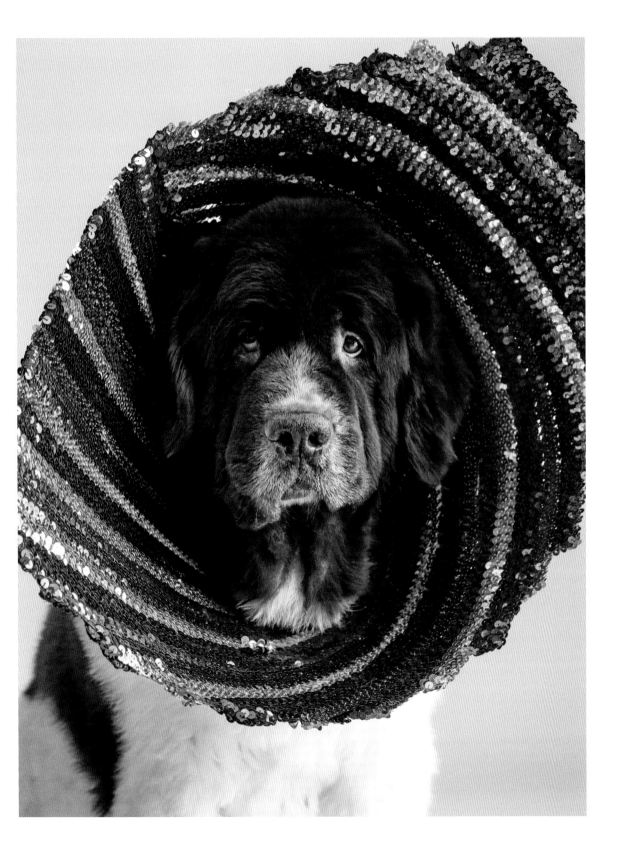

Penn
Newfoundland, 10 years old
Sequin trim on plastic base

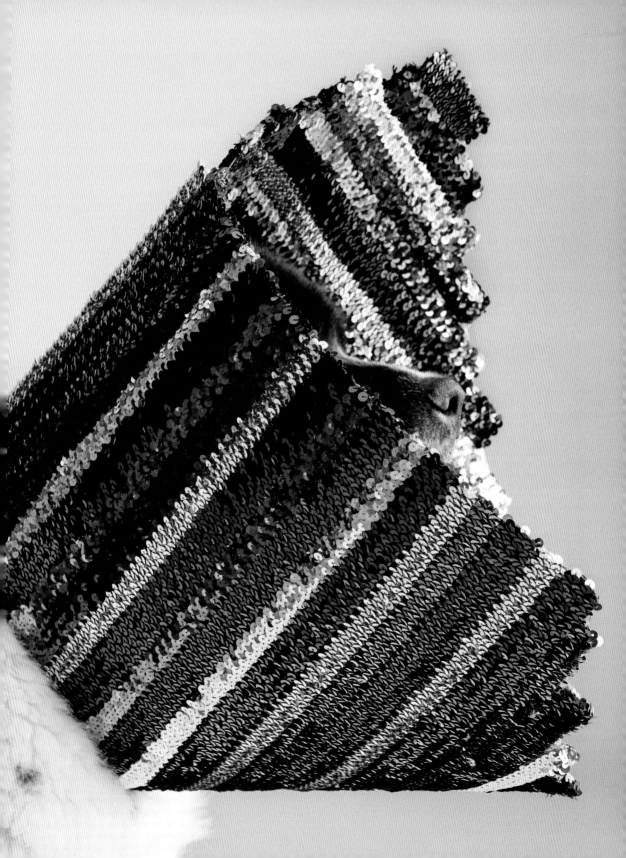

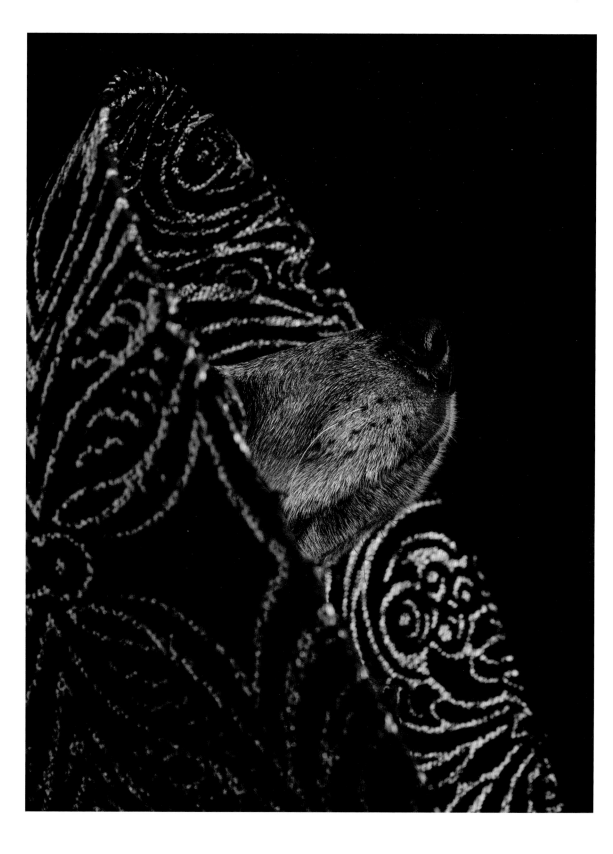

Remy
Australian Cattle Dog, 4 years old
Fabric on plastic base

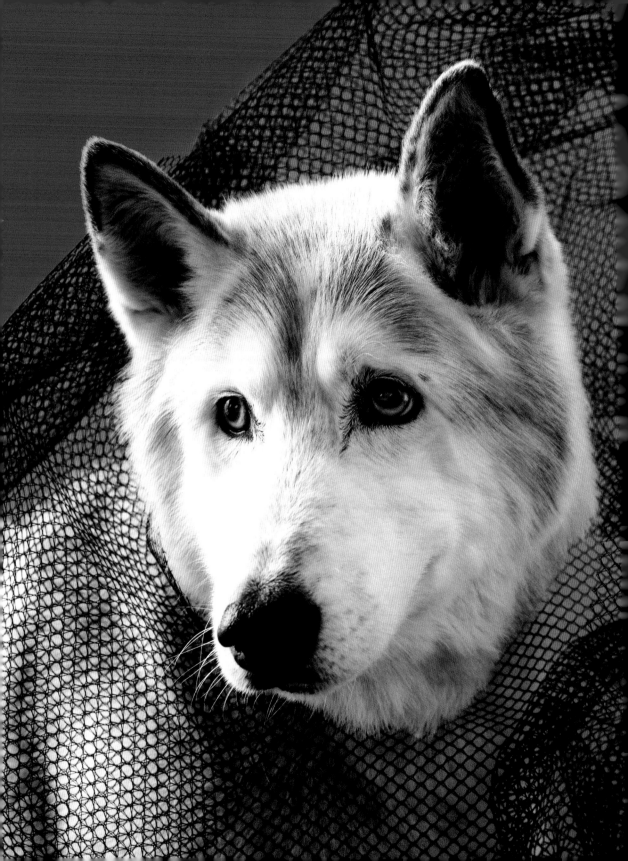

Beau
Siberian Husky, 16 years old
Mesh fabric

Bodhi
Shepherd Mix, 4 years old
Dissolvable insulation foam
on plastic base

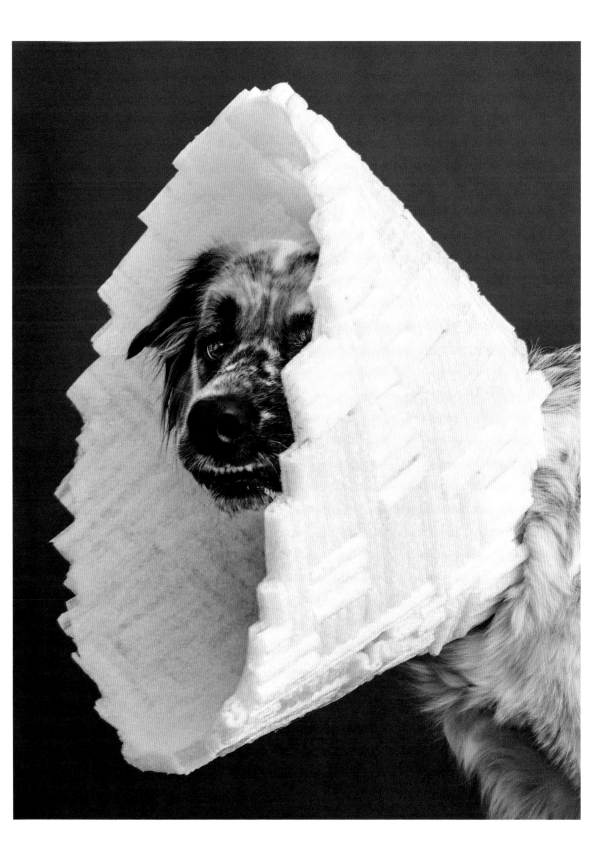

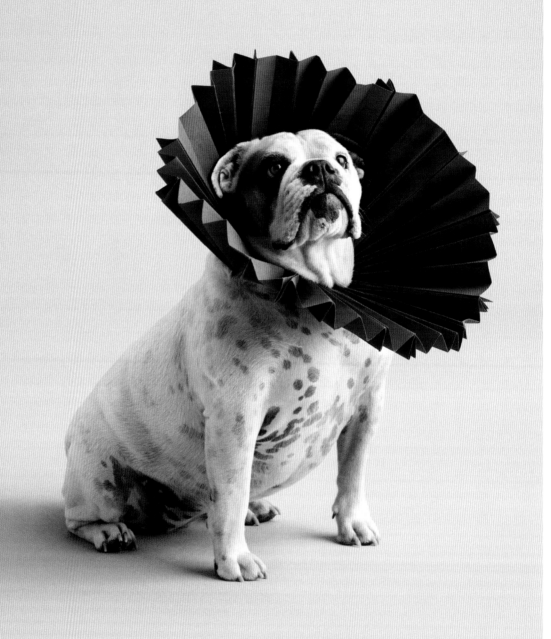

Izzy
English Bulldog, 2 years old
Folded paper

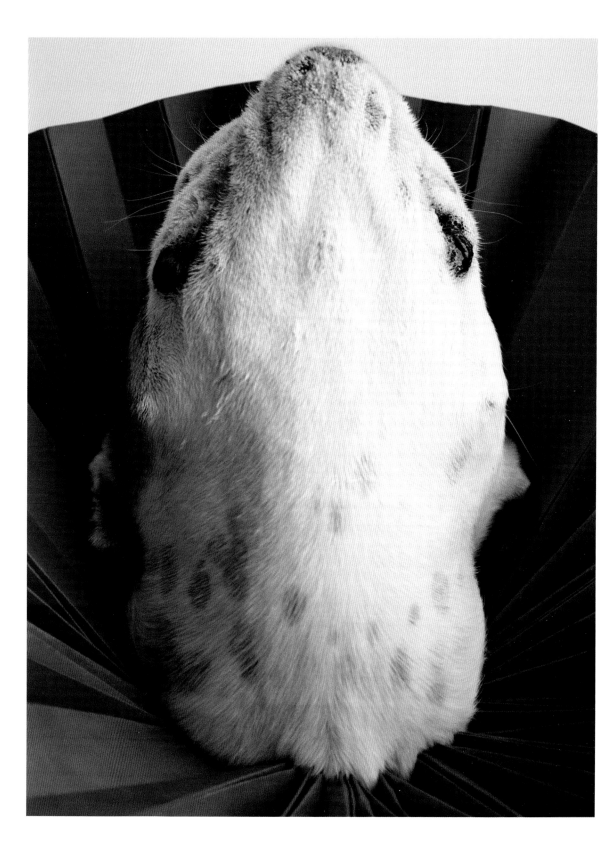

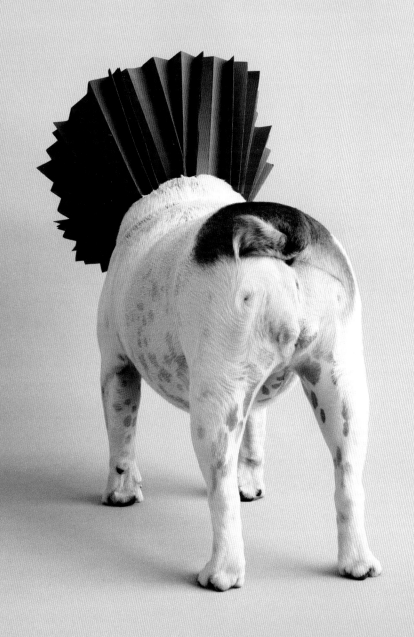

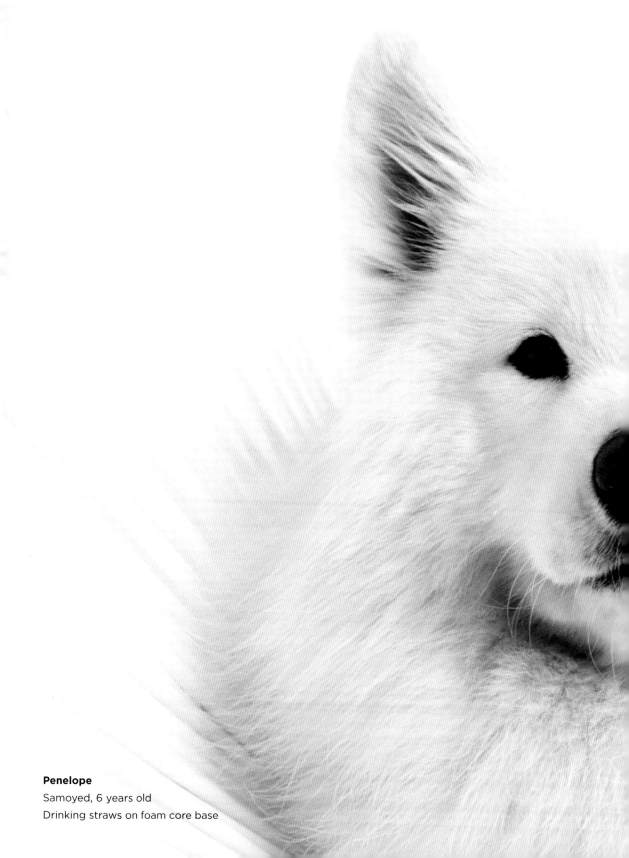

Penelope
Samoyed, 6 years old
Drinking straws on foam core base

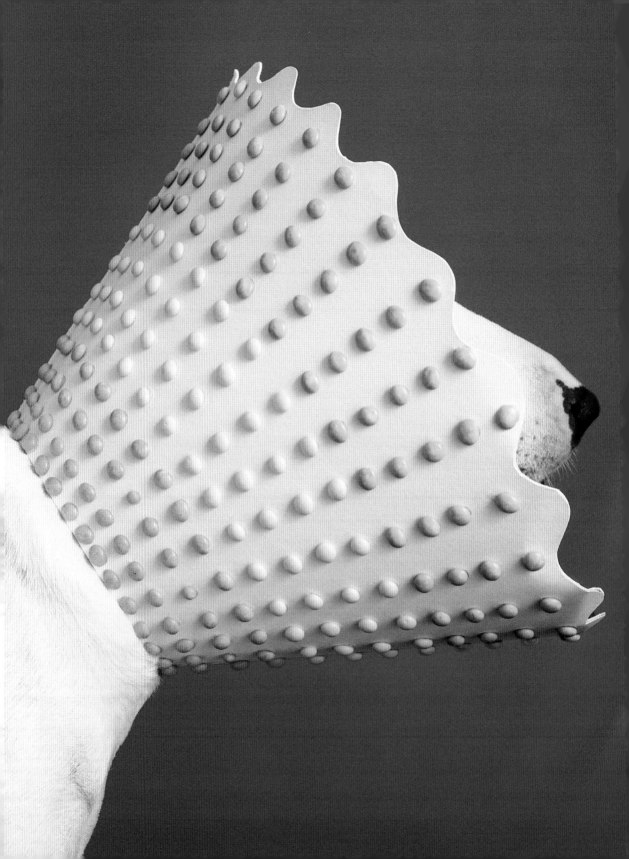

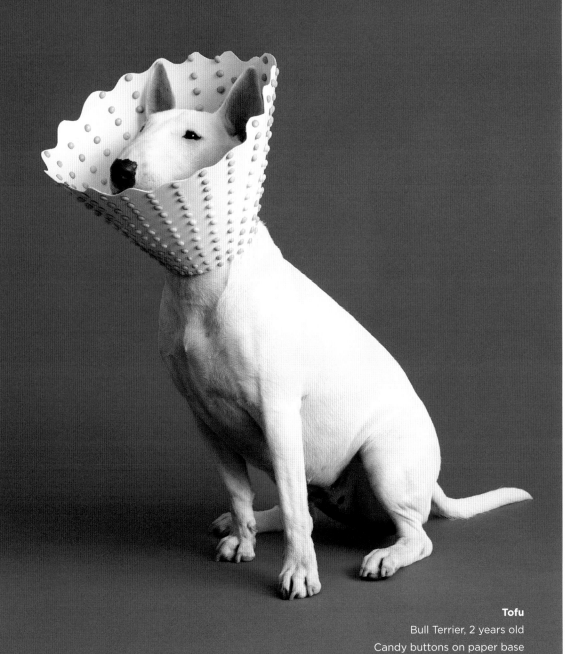

Tofu
Bull Terrier, 2 years old
Candy buttons on paper base

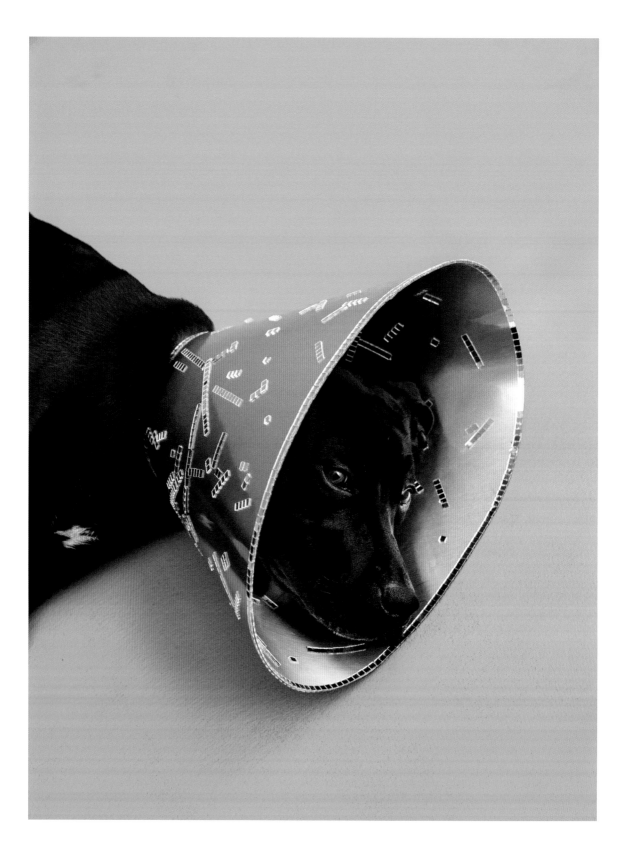

Gaia
Pit Bull–Lab Mix, 2 years old
Disco ball mirrors and metallic
silver paper on plastic base

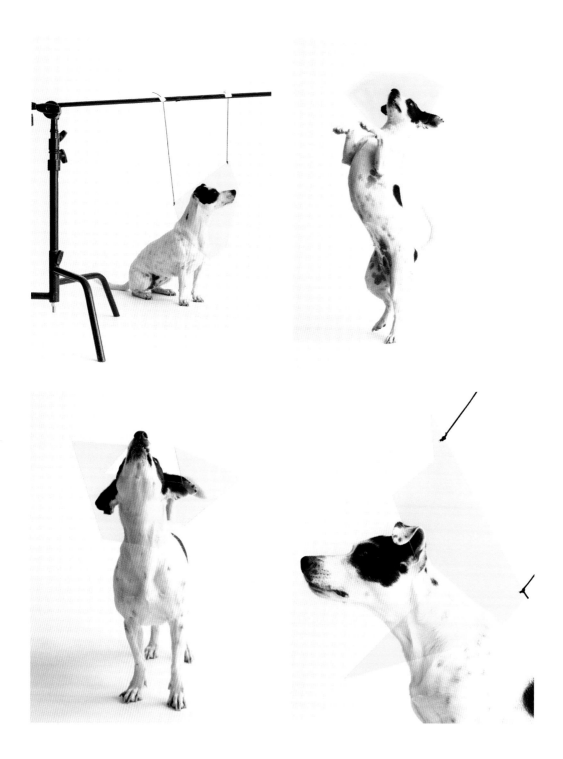

Gertie
Potcake, 4 years old
Plexiglass, black string, C-stand, white tape

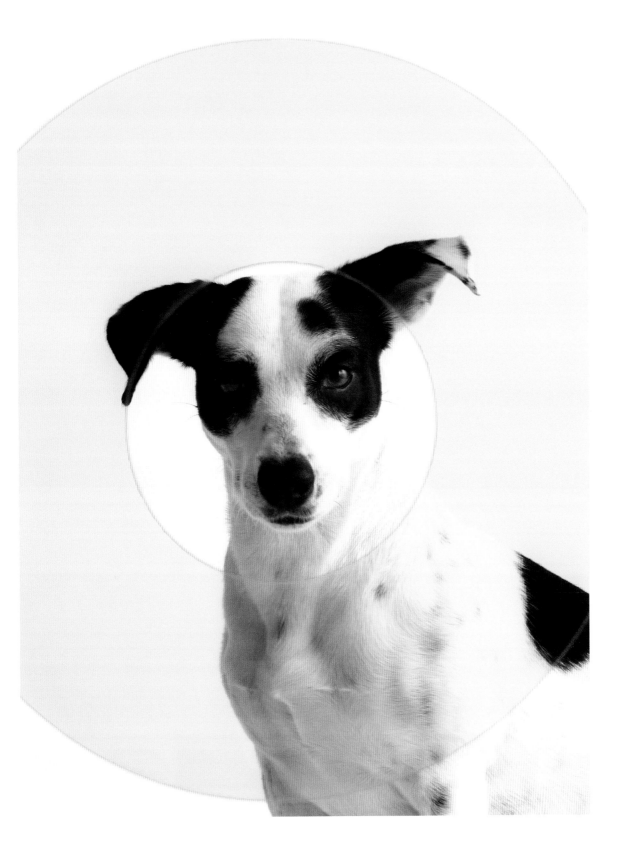

Momo

Corgi, 4 years old

Trim/mixed materials on plastic base

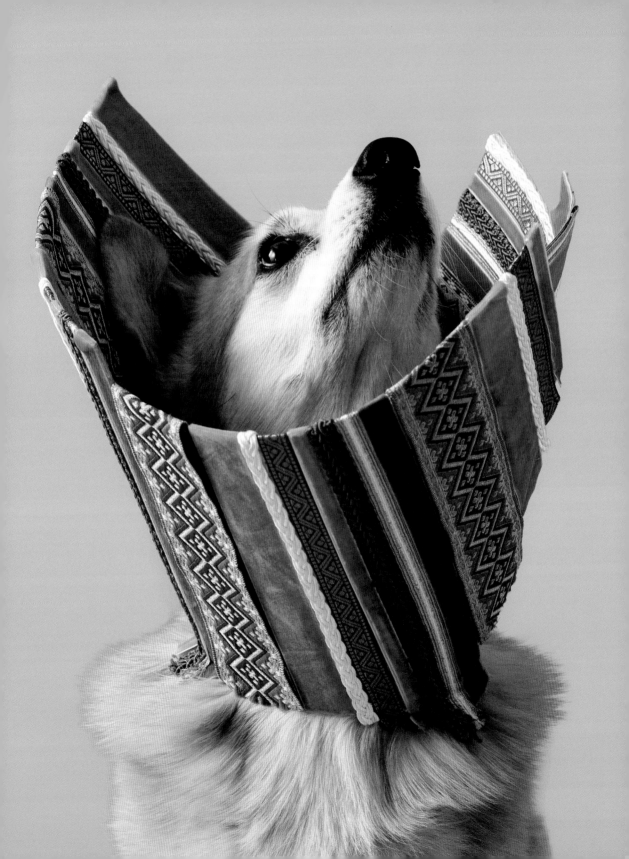

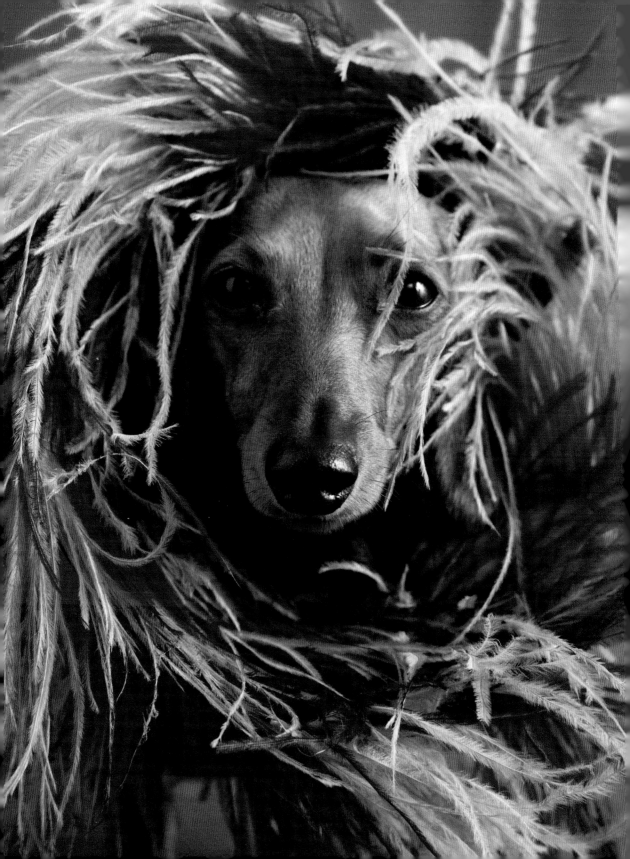

Honeynut
Miniature Dachshund, 2½ years old
Artificial ostrich feathers on plastic base

Bowie
Native American Indian Dog, 6 years old
Faux fur on plastic base

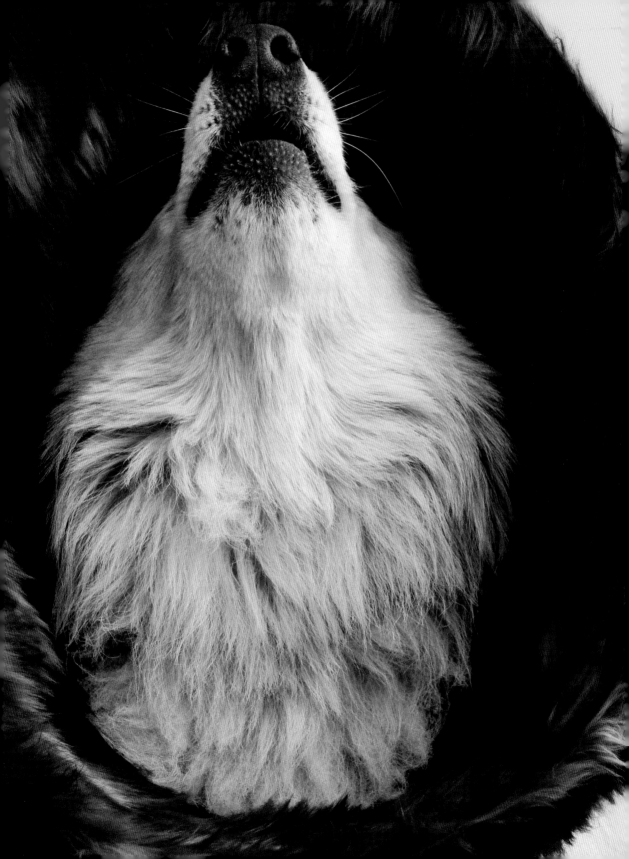

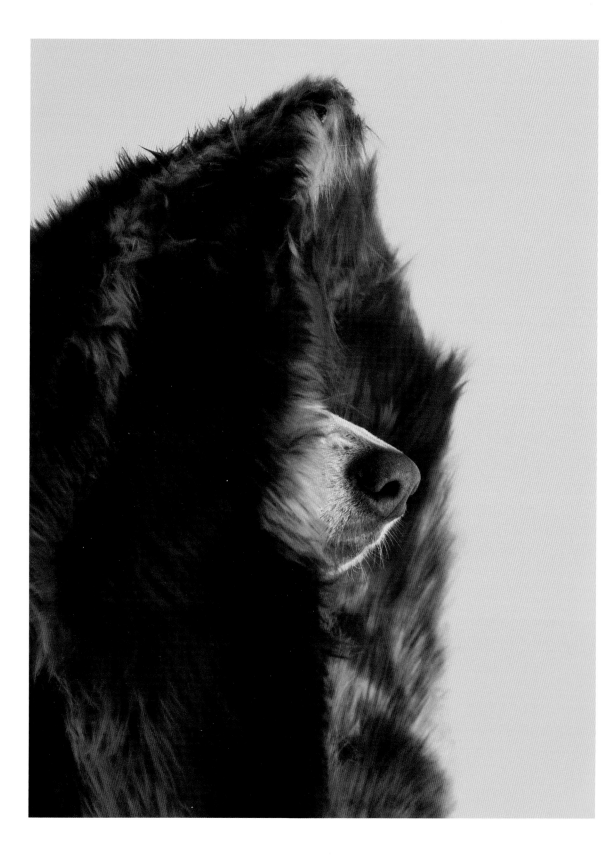

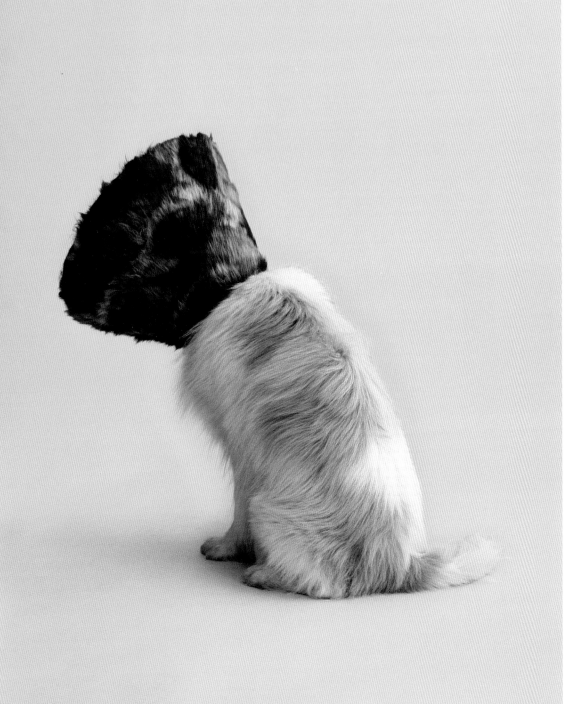

Slayer

Boxer, 2 years old
Plaid fabric on plastic base

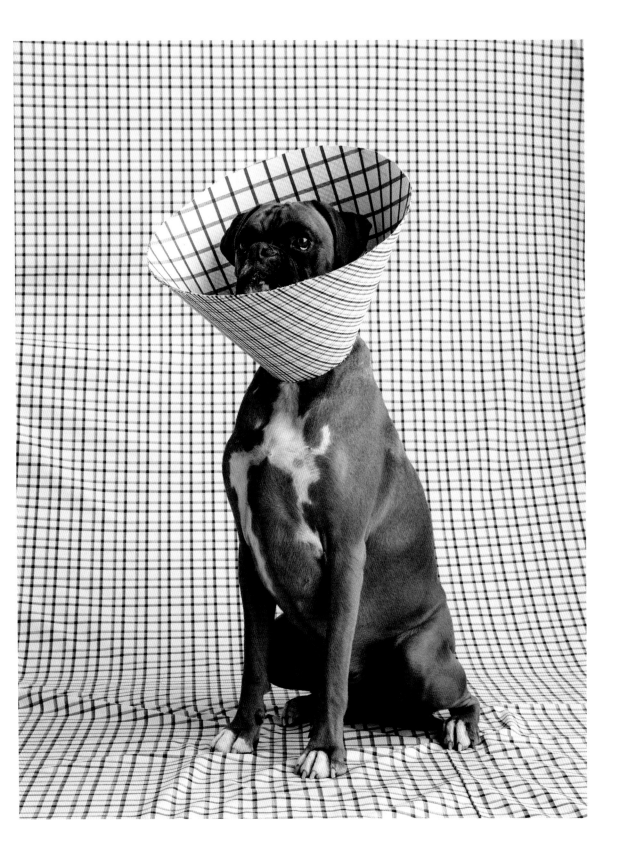

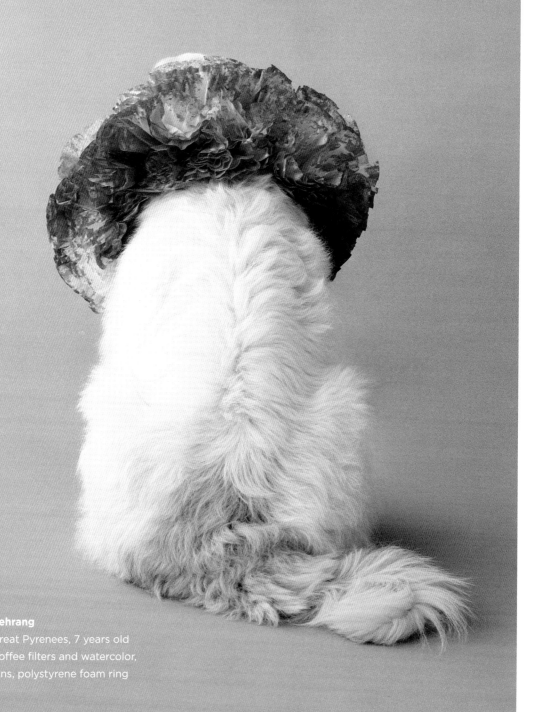

Behrang
Great Pyrenees, 7 years old
Coffee filters and watercolor,
pins, polystyrene foam ring

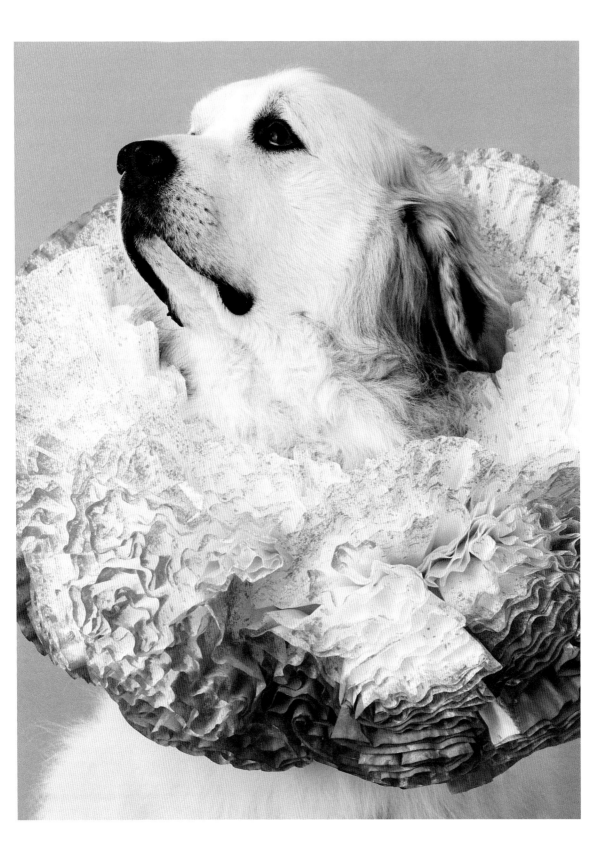

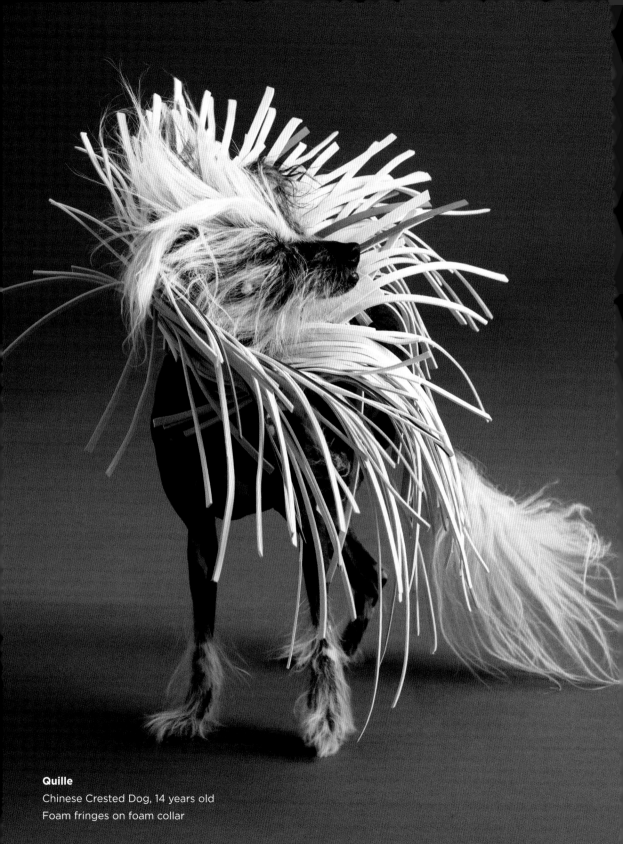

Quille
Chinese Crested Dog, 14 years old
Foam fringes on foam collar

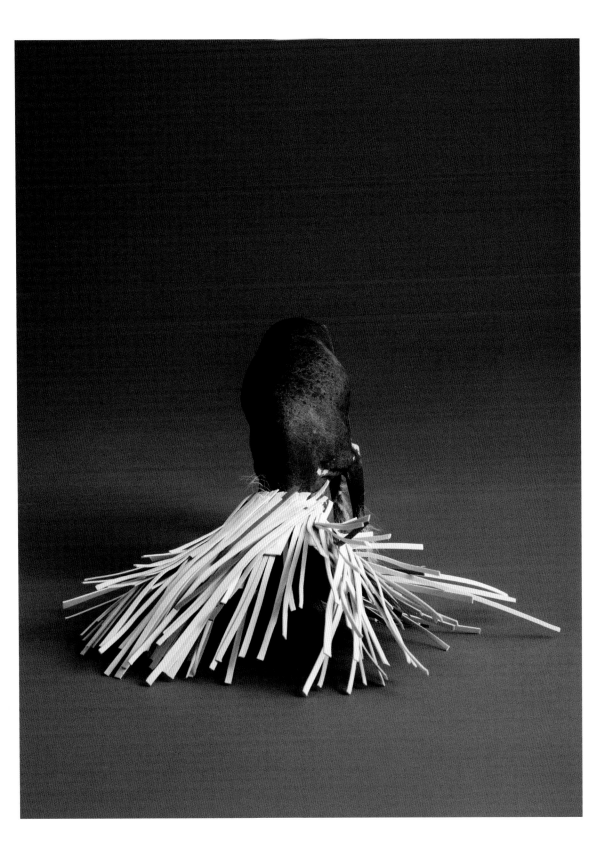

Possum

German Shorthaired Pointer, 10 years old
Cow-print suede fabric on paper base

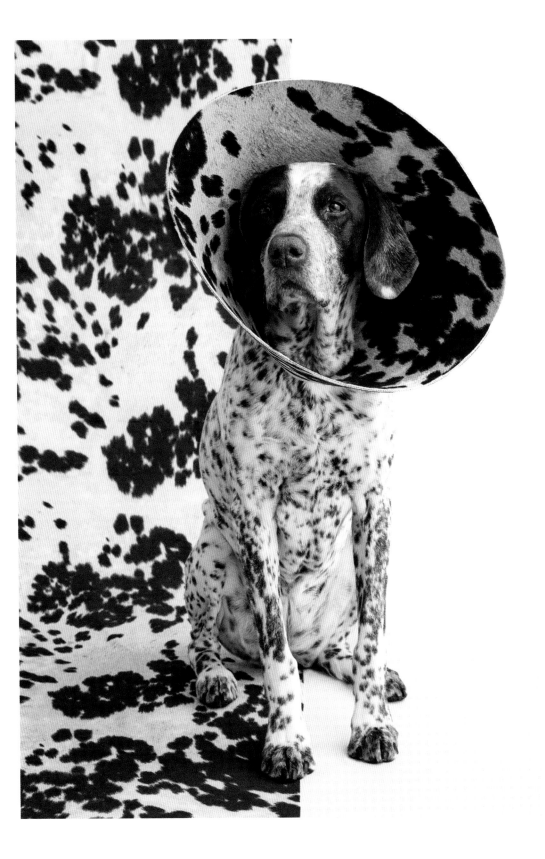

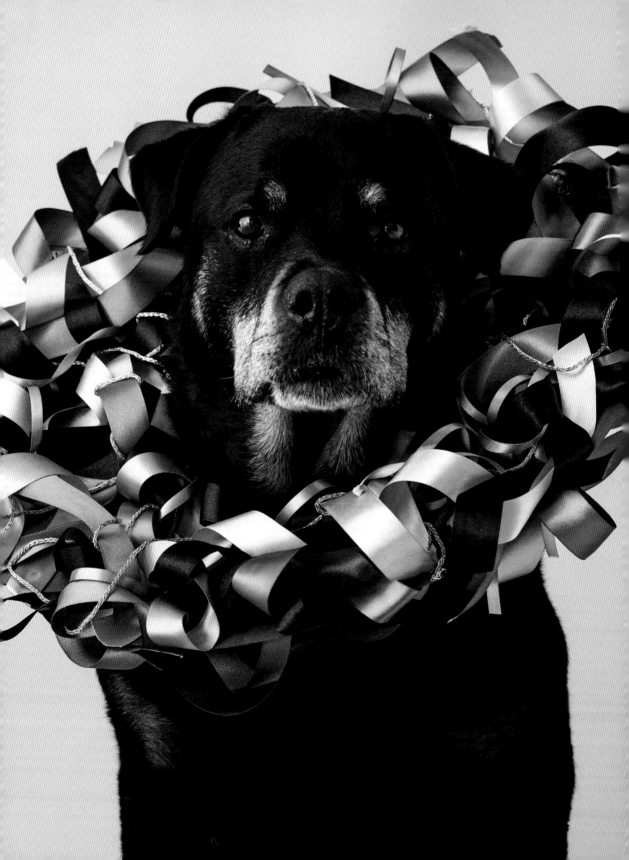

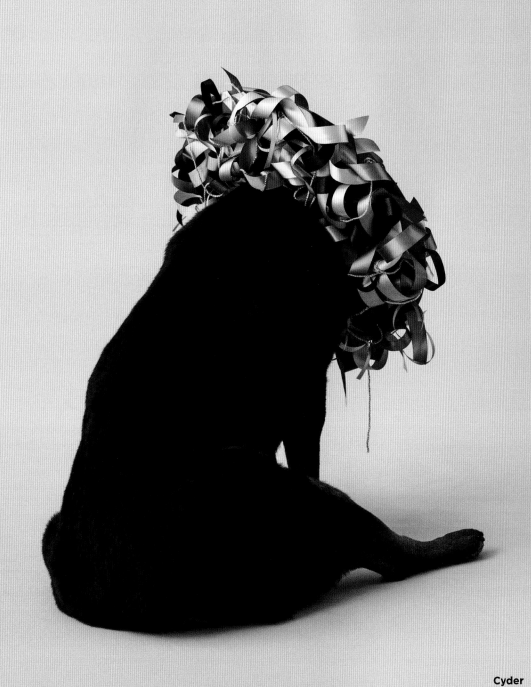

Cyder
Rottweiler, 12 years old
Satin ribbons, gold thread on paper base

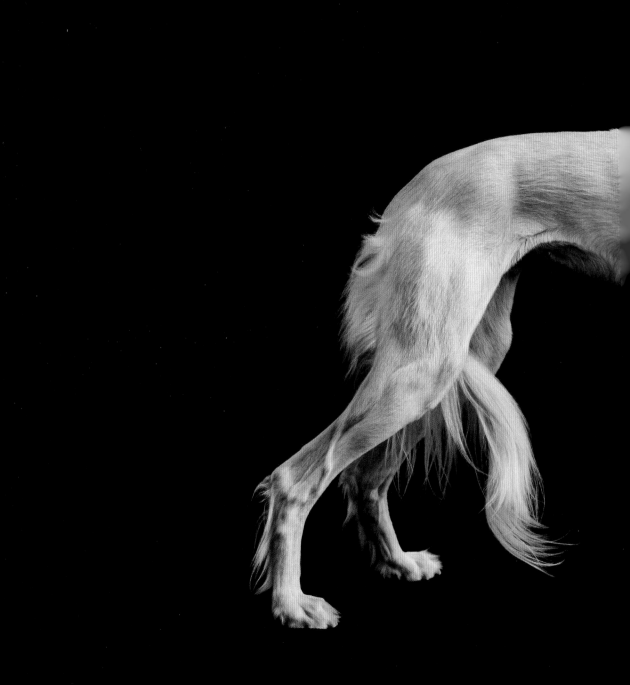

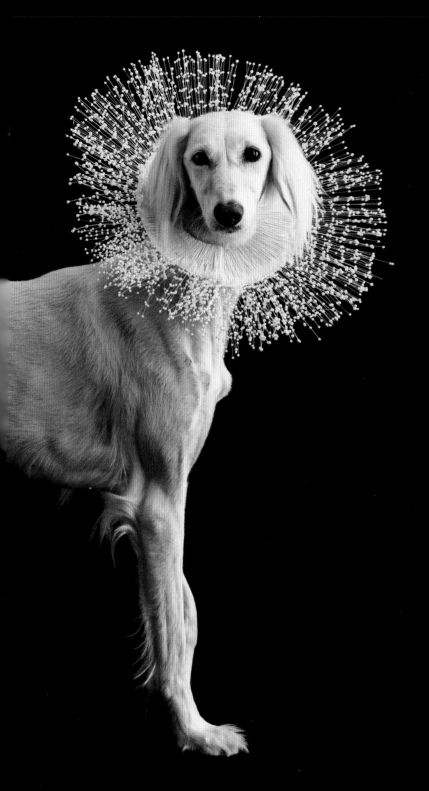

Lola
Saluki, 3 years old
Beaded florist's sticks on paper collar

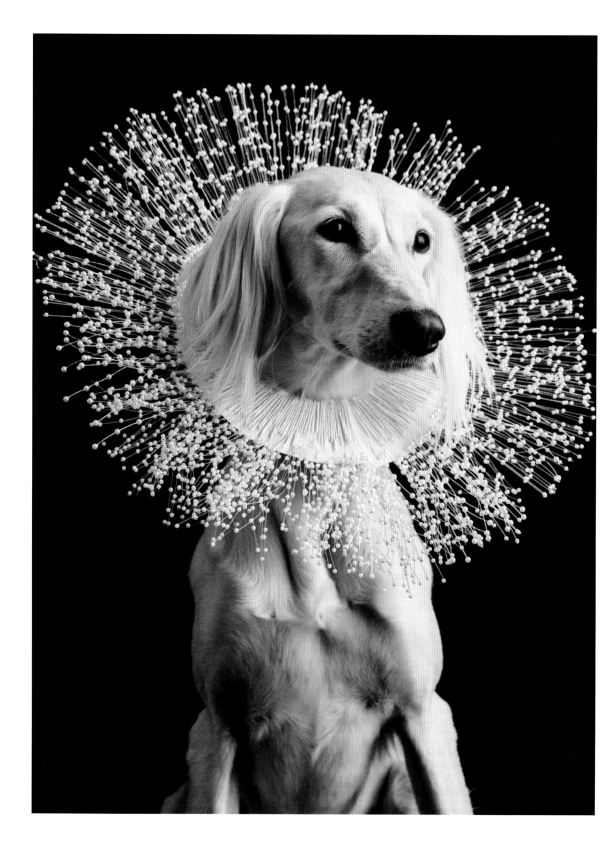

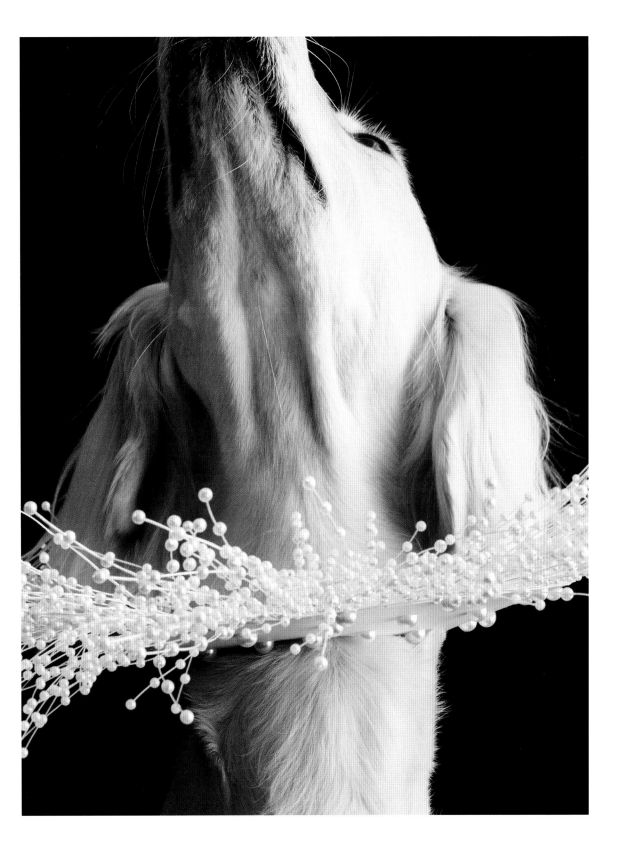

Sebi
Brussels Griffon, 7 months old
Artificial grass on plastic base

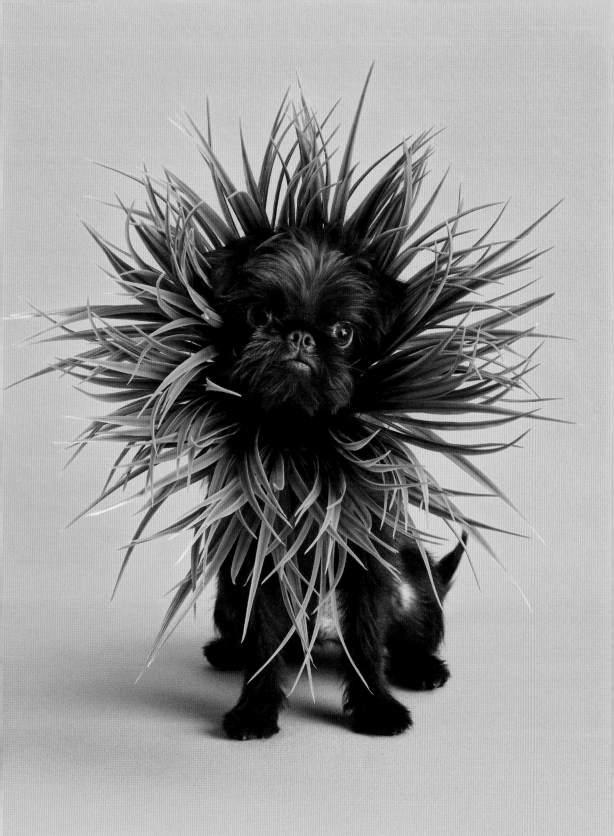

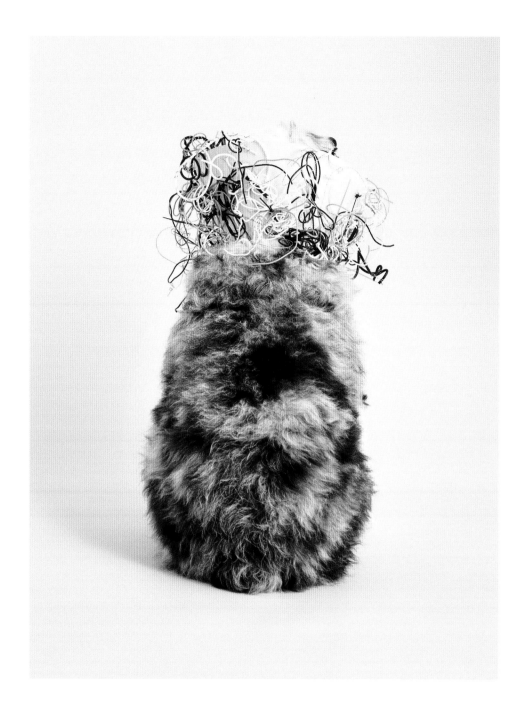

Tsuki
Mini Aussiedoodle, 2½ years old
Paper and electric wires, zip ties
on plastic and paper base

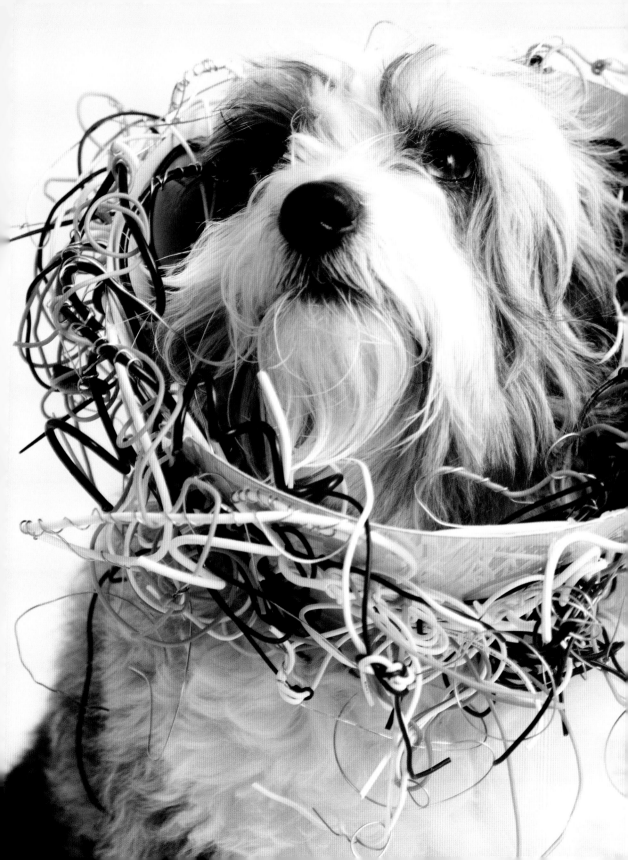

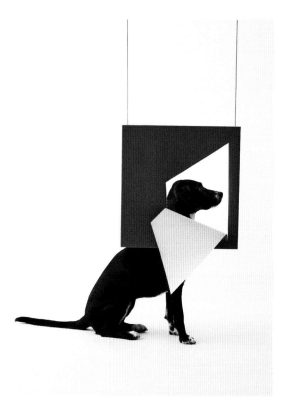
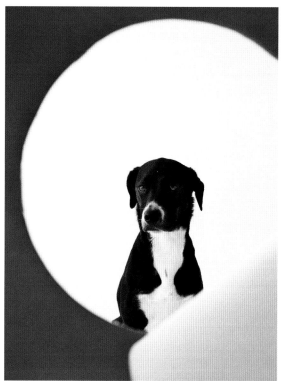

Leica
Boxer Mix, 3 years old
Canvas and acrylic paint, black string

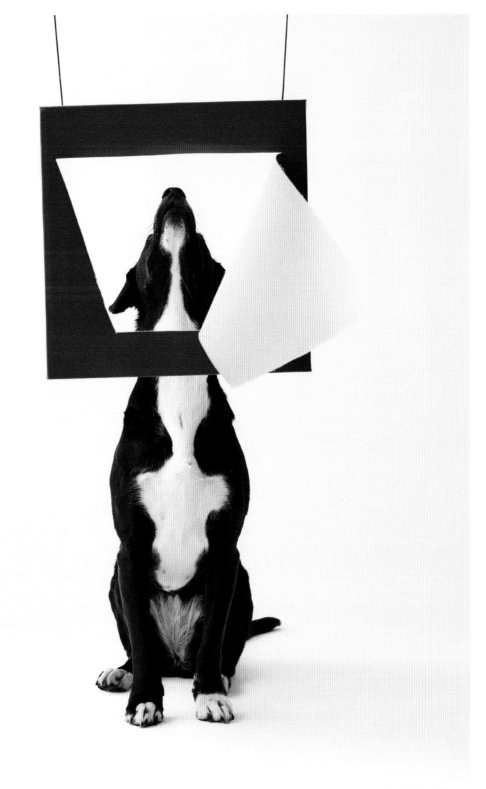

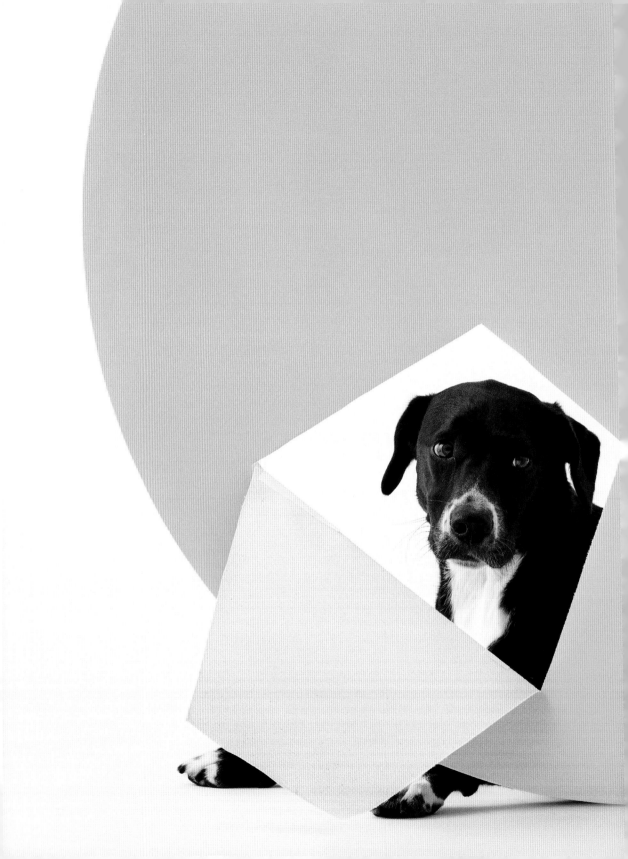

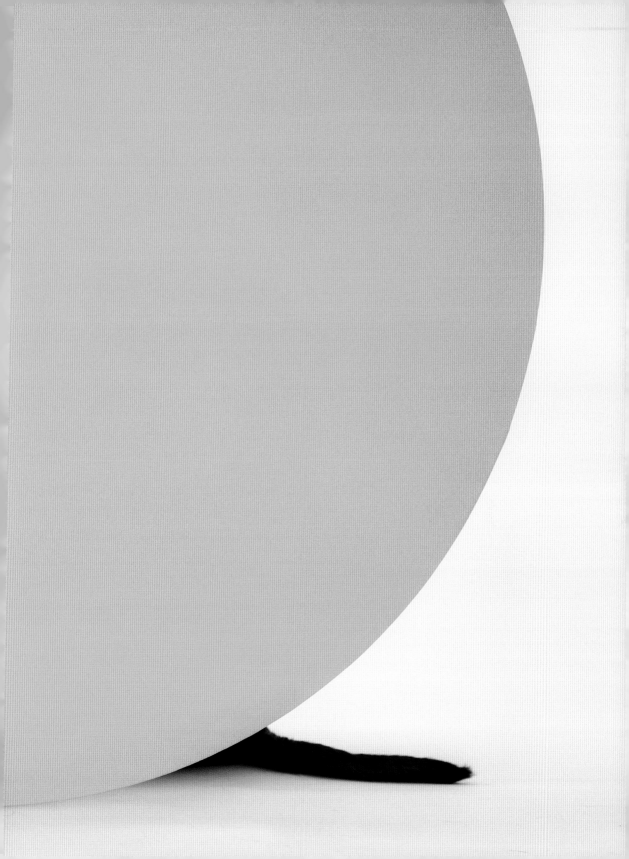

Collagio
Great Dane, 11 years old
Eggshells and black acrylic
paint on plastic base

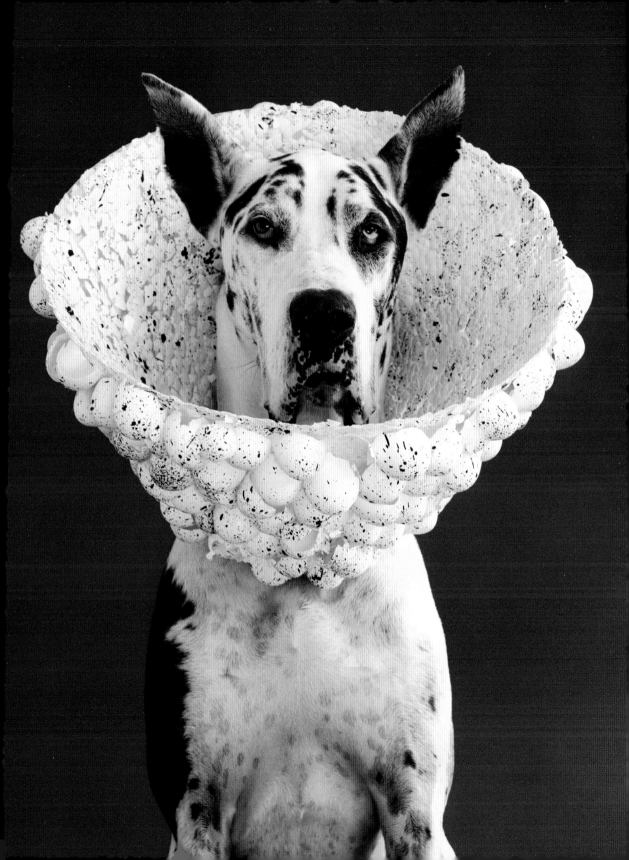

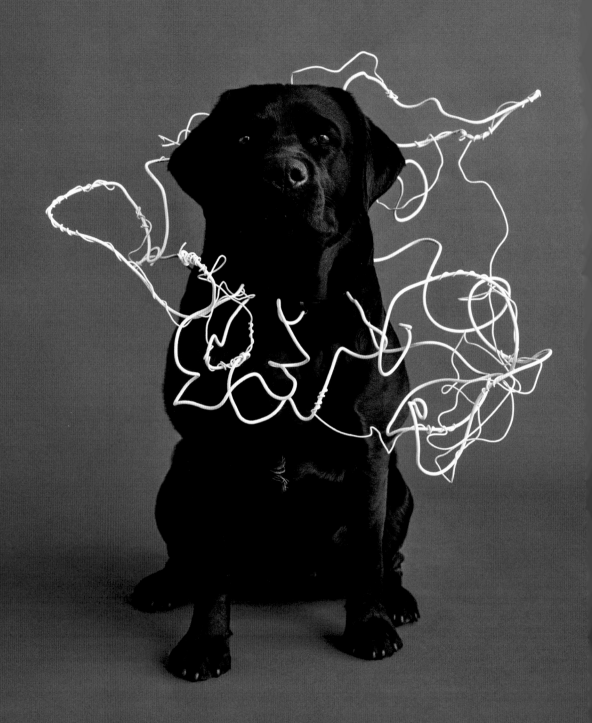

Jojo
Labrador Retriever, 3 years old
Metal wire and acrylic paint on
a black felt collar

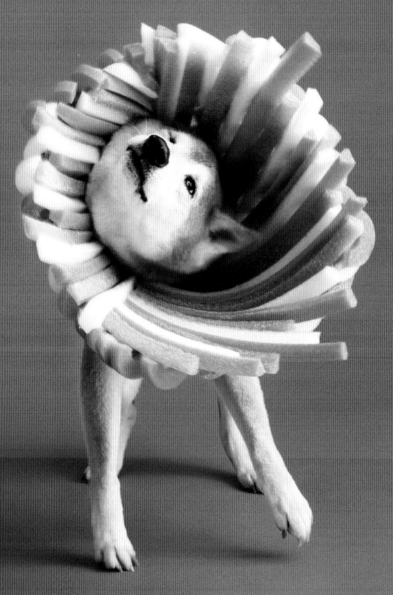

Bodhi (aka Menswear Dog)
Shiba Inu, 13 years old
Pool noodles on plastic base

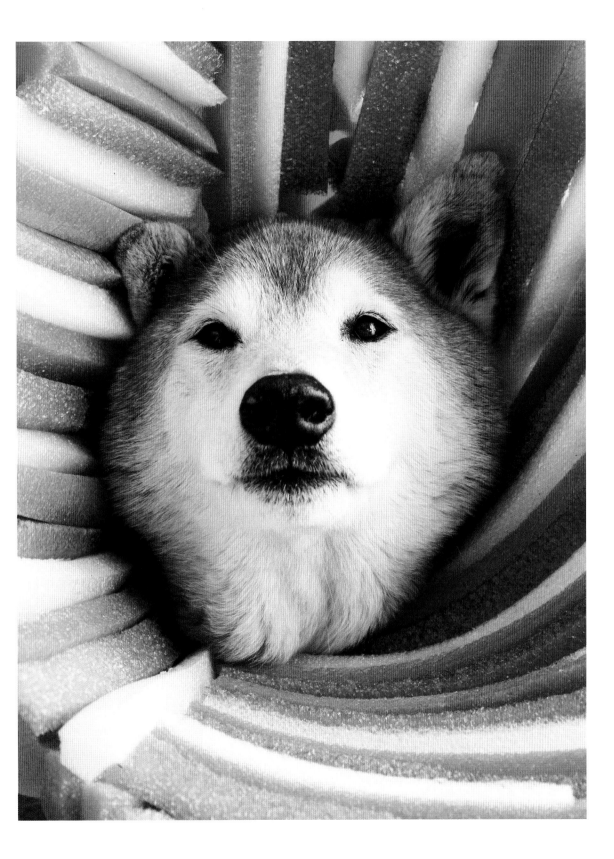

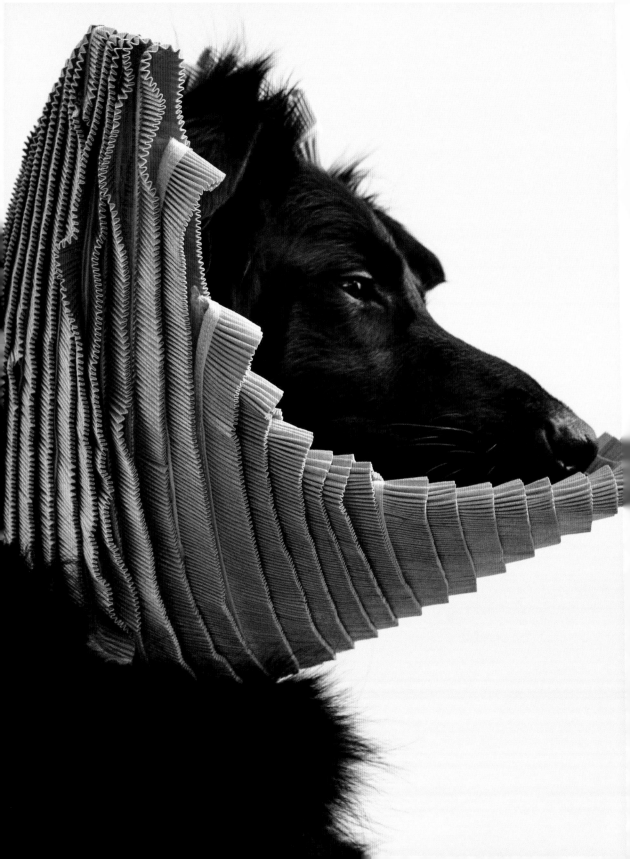

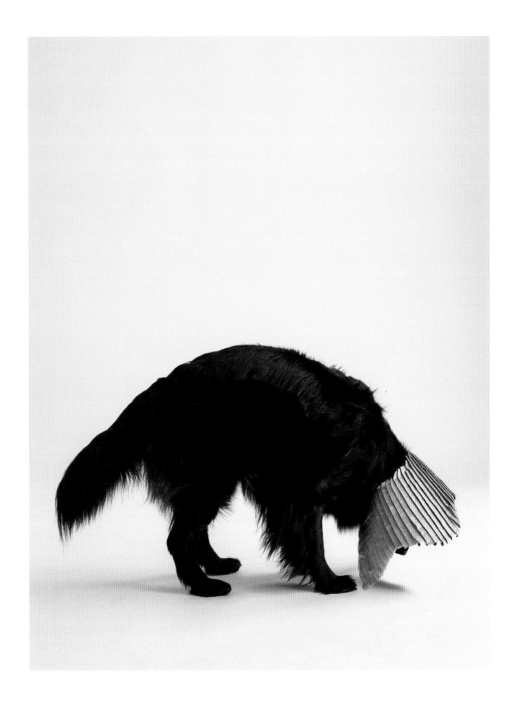

Otis
Golden Retriever–German Shepherd Mix, 3 years old
Satin trims on plastic base

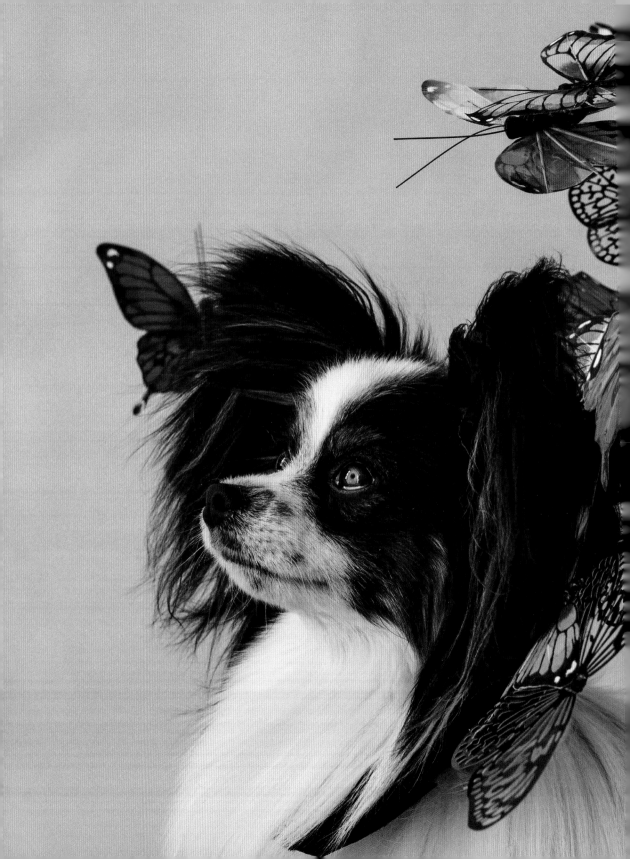

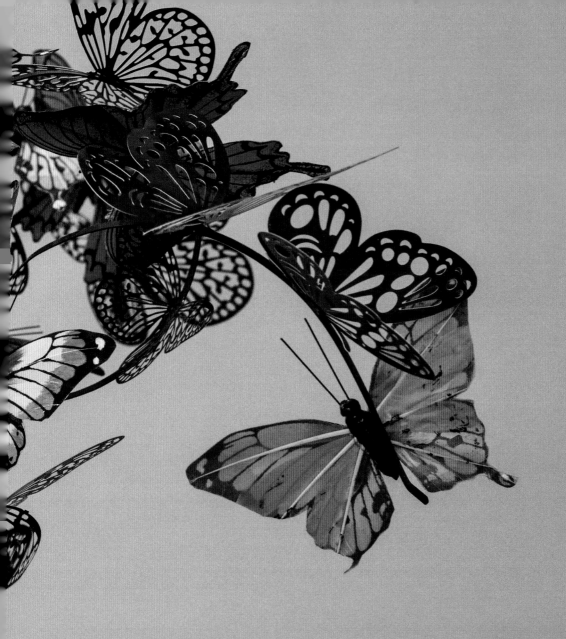

Finley
Papillon, 1 year old
Artificial butterflies and
metal wires on black felt collar

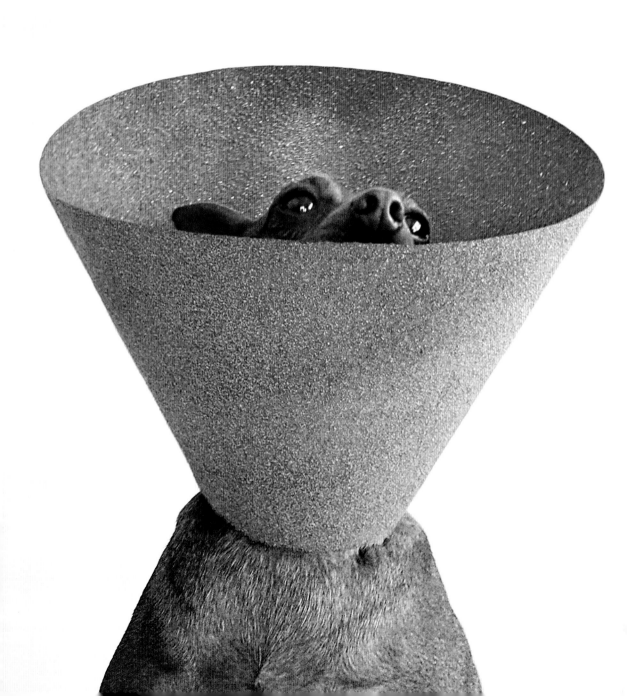

Mishka
Miniature Pinscher, 10 years old
Sand on paper base

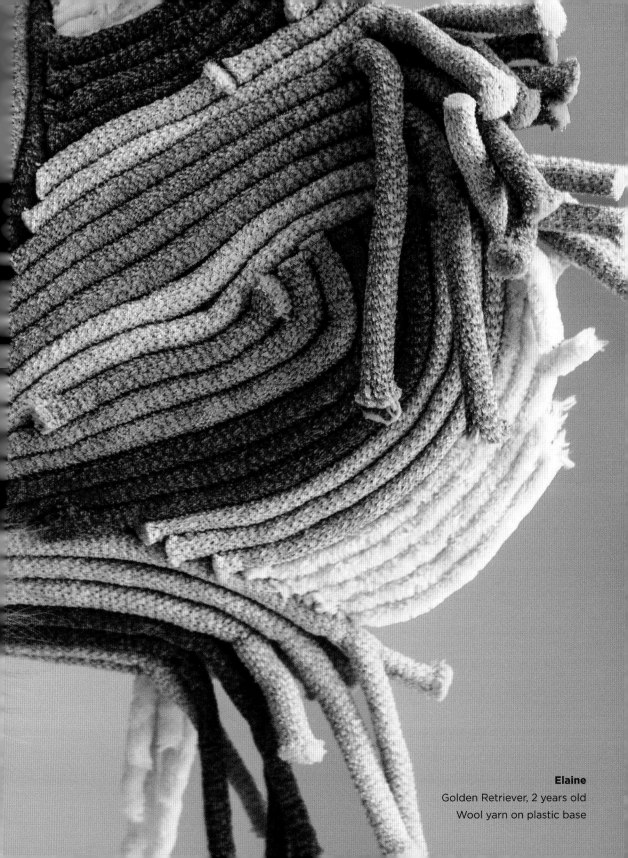

Elaine
Golden Retriever, 2 years old
Wool yarn on plastic base

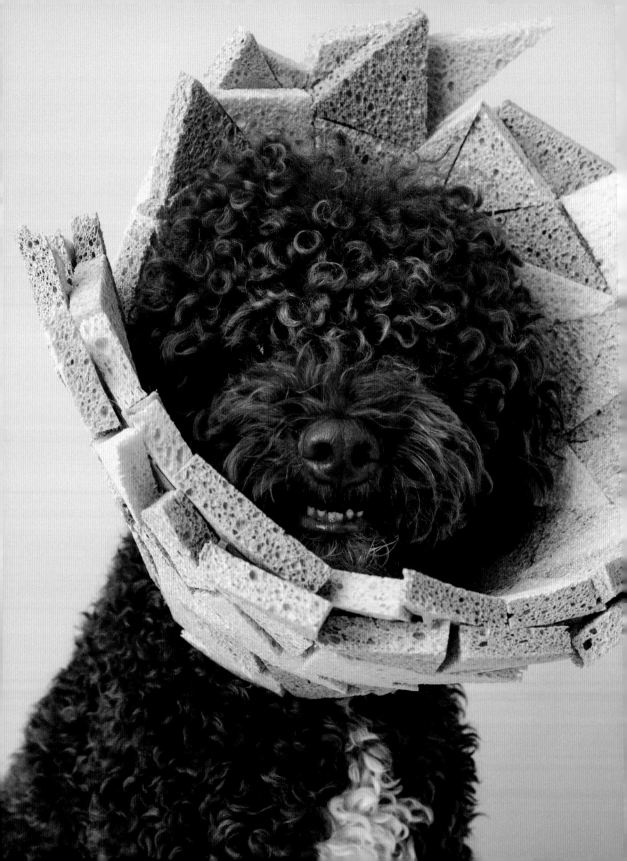

Logo
Lagotto Romagnolo, 2 years old
Multicolored sponges on plastic base

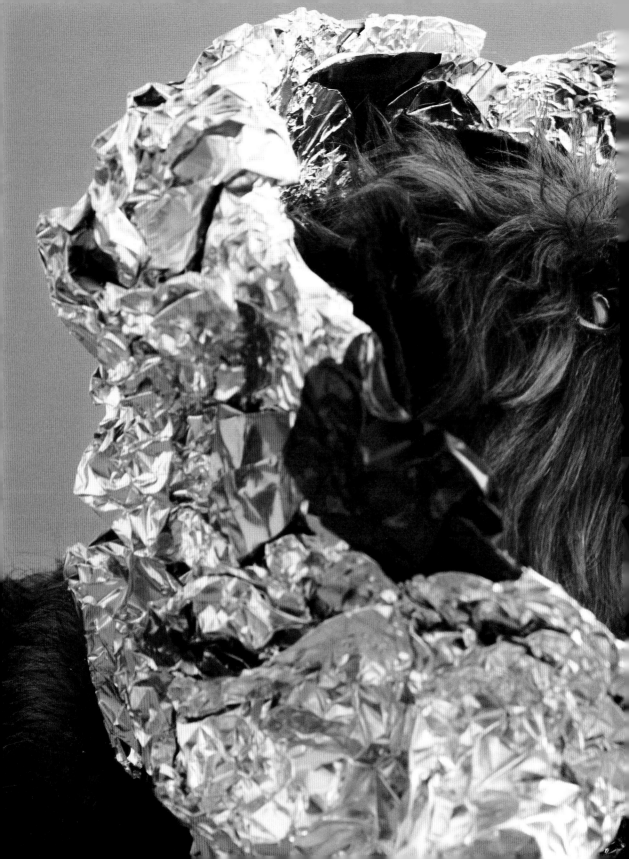

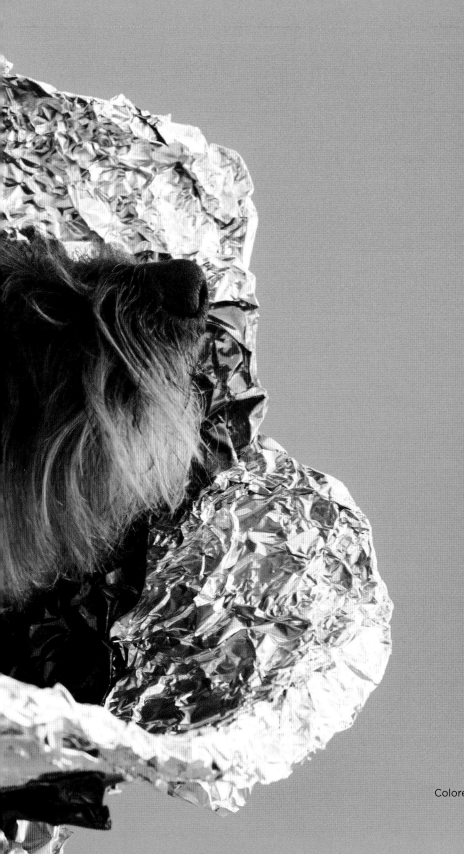

Nia
Terrier Mix, 5 years old
Colored and silver aluminum
foil on plastic base

Toblerone ("Toby")
Spaniel-Retriever Mix, 10 years old
Fabric on plastic base

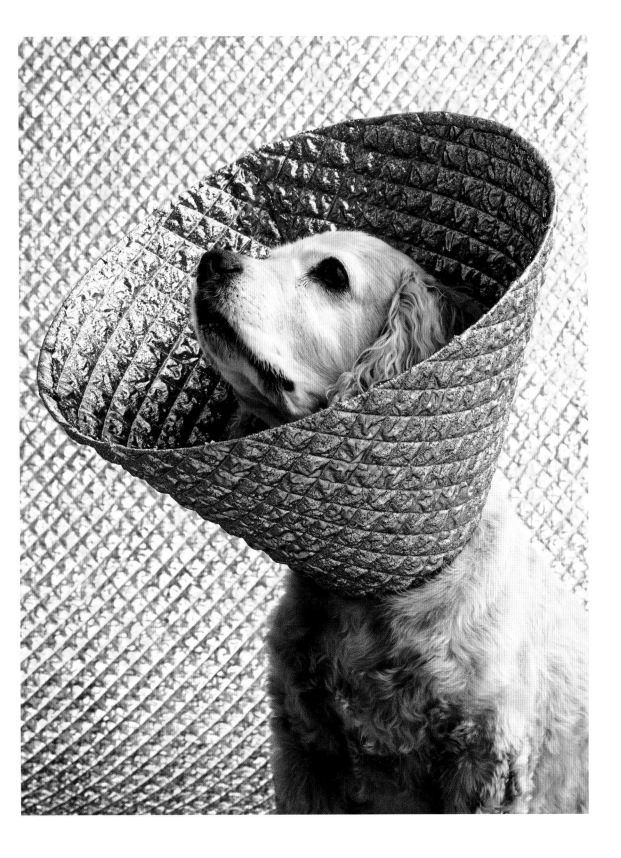

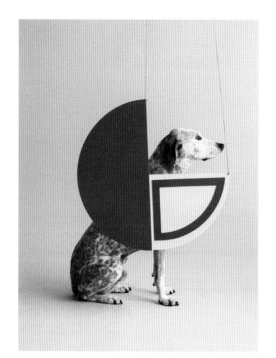
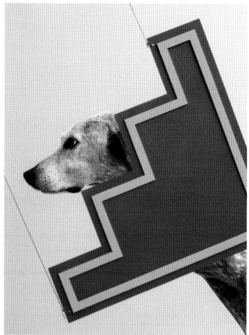
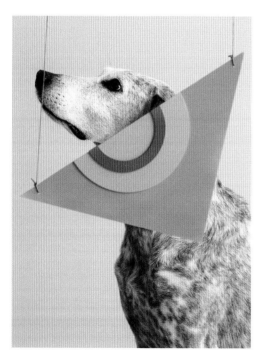
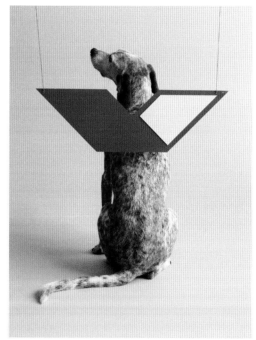

Henry McGoober
American English Coonhound, 12 years old
Plexiglass, acrylic paint, string

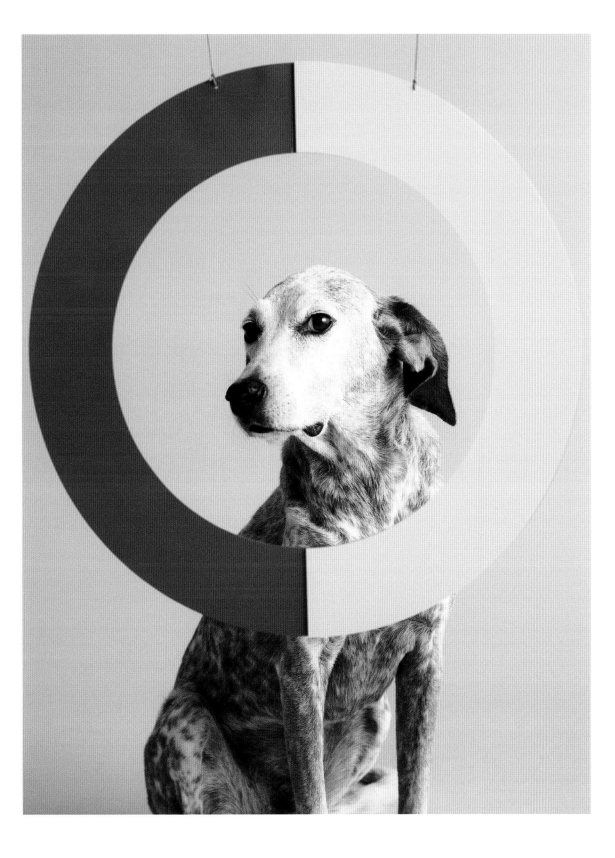

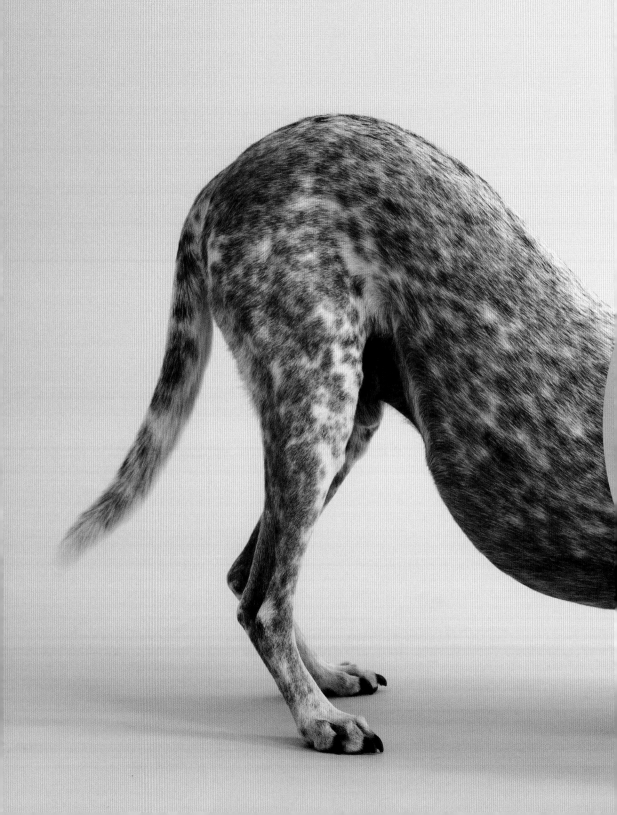

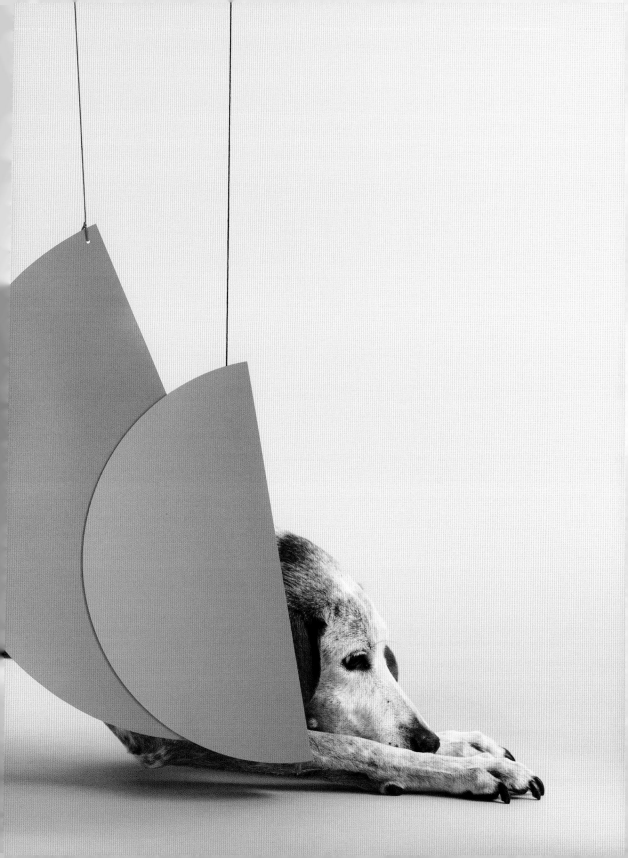

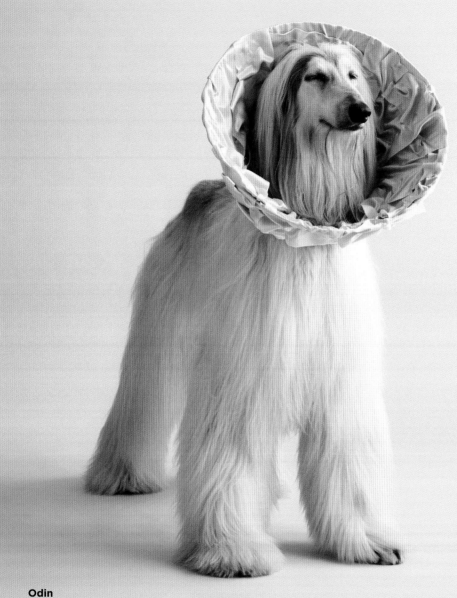

Odin

Afghan Hound, 3 years old

Satin fabric on plastic base

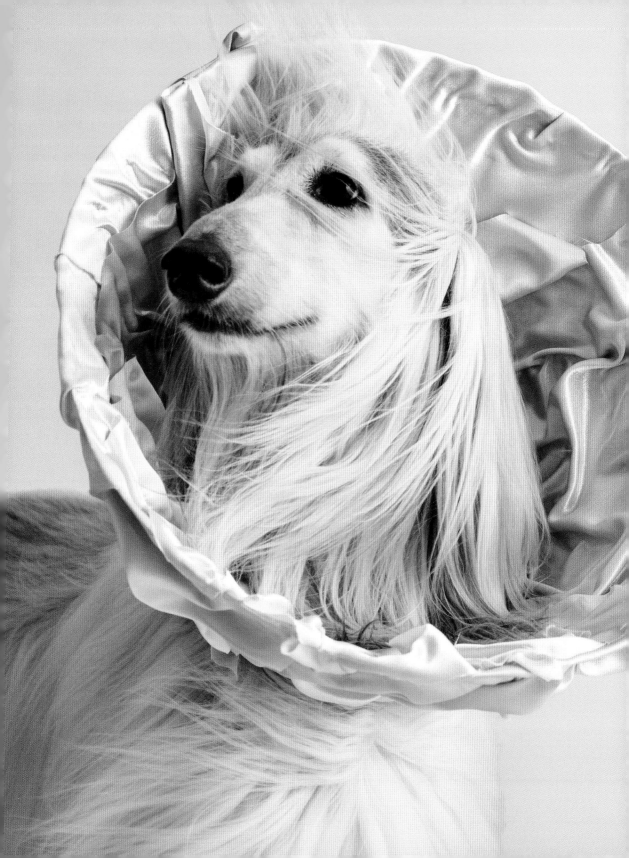

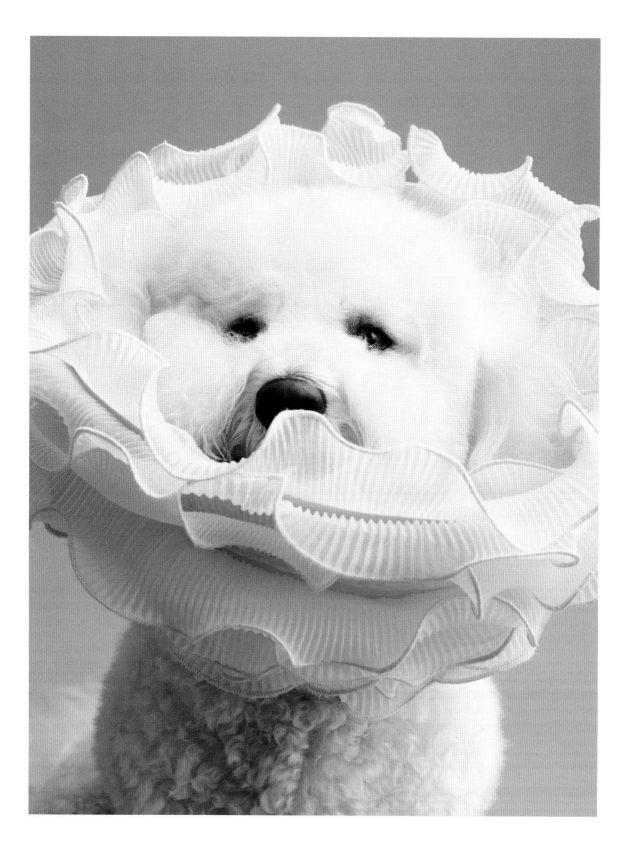

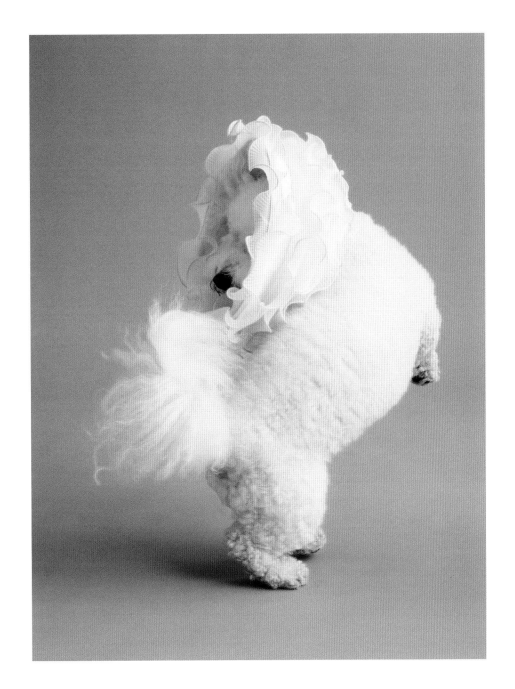

Rycher
Bichon Frise–Miniature Poodle Mix, 3 years old
Fabric trim on paper base

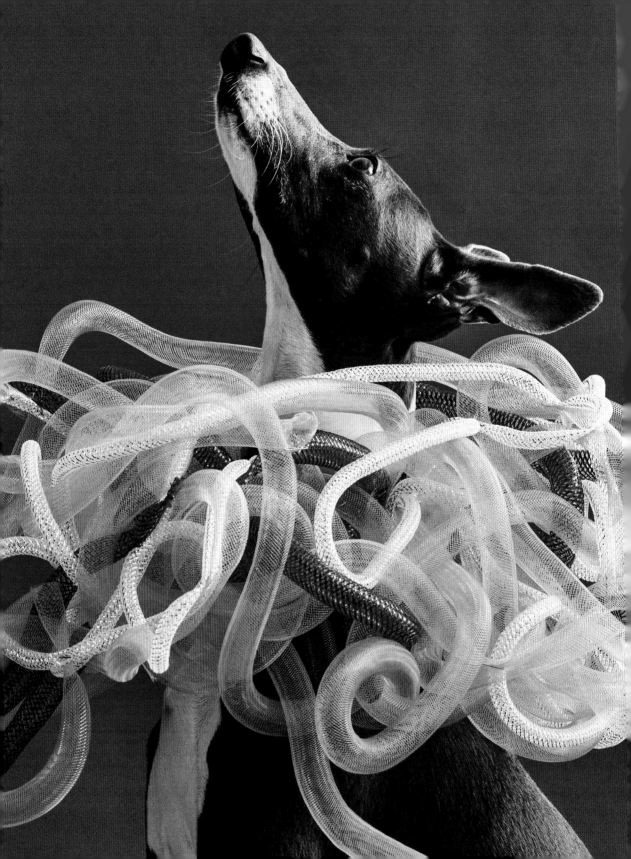

Brutus
Italian Greyhound, 3 years old
Mesh tubing on fabric collar

Clementine
Basset Hound, 13 years old
Latex balloons on fabric collar

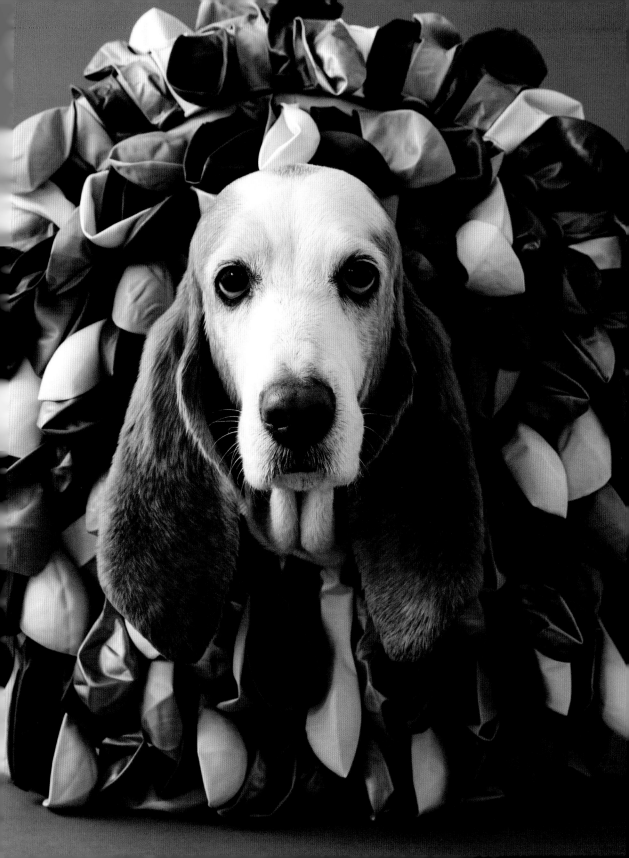

ACKNOWLEDGMENTS

Making *Cone of Shame* was a labor of love, and I couldn't have done it without the help of so many wonderful people and dogs.

I want to first thank cone designer Marie-Yan Morvan for collaborating on the Cone of Shame project for so many years. I couldn't have done it without you, and I will miss our very serious back-and-forth discussions about dog breeds, fur and backdrop colors, and, of course, cones. Your eye is impeccable, your work ethic unparalleled, and I couldn't have asked for a better partner on this series.

To Marta Roca, thank you for all your help advising on the design of these pages and guiding the flow and edit of the images. Your creative input helped make this book what it is, and I couldn't have done it without you. I'm so thankful for our shared love of dogs and our many years of collaboration.

I'd like to thank Amanda Englander for loving basset hounds and being the spark that helped turn the Cone of Shame series into this beautiful book; my editor, Jay Sacher, and creative director Lisa Forde, for your trusted help and direction; Melissa Farris, for your help with all the layouts and design; and everyone else at Union Square & Co. and Barnes & Noble for believing in this project. It has been a huge pleasure to be able to explore this series in much more depth, and the dogs and I will always appreciate it.

Many thanks to all my crew—especially Sam Dong, Will Crakes, and Luca Seixas—your help on set made everything here possible. Thanks to Levi Mandel and Alex Schaefer for helping with the BTS footage and to Bonnie Saporetti for being my production and organizational wizard. To Viviana Lucia for helping me cast dogs and for your continued support throughout the years. To Shio Studio and Prospect Studios, thanks for providing the backdrop for our many photo shoots. To Cat Long at All Creatures Great & Small, for your expertise with animals and help on many shoots. To Lou Bank, Olivia Johnson, and my crew and interns from 2017, thanks for helping with the original conception of this series.

To everyone on the internet who helped spread the word about *Cone of Shame* so that I could find the best dog models out there, thank you. And to my retouchers at Feather Creative, thanks for working with me to make these photos sing. To the folks at The Photoville FENCE and Fotografiska, thank you for helping to bring the original Cone of Shame series to audiences around the US and the world. To all the editors who have found and shared the series in news articles, thank you for appreciating this project and helping to spread the word.

Special thanks to Ann-Marie Gardner for being my spiritual dog guide throughout this process. To Karen Day for your help and advice on the copy side. To Lori Lefevre for advising me about spreading the word. To Yena Kim for all your support and for truly understanding the intersection of dog and art. To my agent, Natalie Flemming at This Represents, for being as dog-obsessed as I am, understanding my vision, and always being there for me. And to everyone else at This Represents who work tirelessly to help get my work out there.

Thanks to the photography community for your support, especially to all the other moms and new moms out there who have understood this crazy thing we call work-life balance.

Thank you to my parents, Anna and Joseph Au, for being so supportive throughout my photography career, teaching me how to work hard and be thankful, exposing me to the world, and bringing all our first pets—especially our beloved dog Lucky—into my life.

Thanks to my sisters, Alice and Cindy, for being my constant cheerleaders and for your creative and emotional support throughout this process. Special thanks to Callan for helping to shuttle Clementine and Momo to and from set so they could be a part of *Cone of Shame.* To Stuart, Archer, Scarlett, and my giant extended family and in-laws, for cheering on this project even when you are thousands of miles away.

A very special thanks to my husband, Florent, for being my rock and inspiration. Thank you for being the best husband and papa I could ask for. For always listening to me (even when it's anxieties about which is the best dog for a specific cone), for being a true partner in life, for making me and Chloé laugh, and for loving dogs just as much as I do. To Chloé, whose favorite words are "doggie" and "chien," and to Clementine, for being a fabulous model and patient sister to Chloé. I love you all.

Lastly, to this loving dog community I've found, thank you. Thanks for embracing this book and my vision, and for following me in the journey of creating it. Thanks to anyone who has ever enjoyed seeing my work; bought a print, a book, or notecards; or just shared something of mine that you loved. Thanks to any dog and dog owner I've stopped on the street, for not running the other way and for pausing to listen to what the Cone of Shame is all about. Finding others who are as dog-obsessed as I am in this world has been a joy, and I have loved meeting each and every one of you.

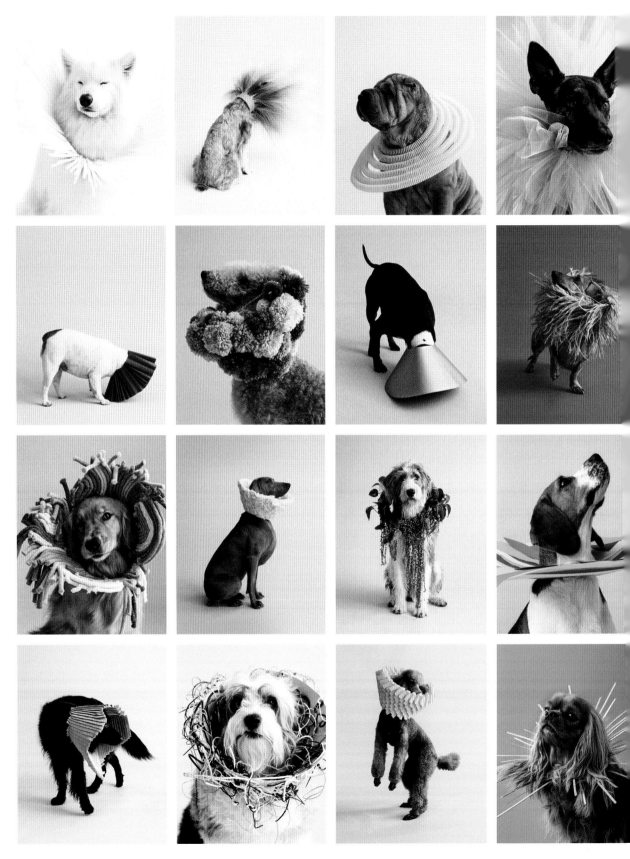

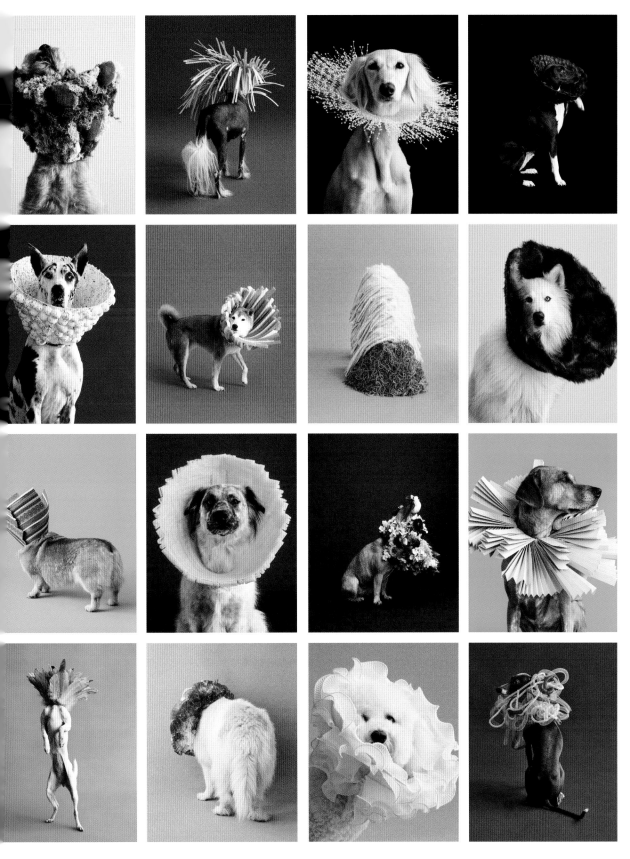

THANK YOU

Special thanks to the wonderful dogs and humans who spent time with us on countless photo shoots making this book.

Agnes
Cat Tyc

All Creatures Great & Small
Cathryn "Cat" Long

Andele
Dina

Beau
Caroline Loevner

Bee
Franck Raharinosy

Behrang
Azadeh Nematzadeh & Jake Swiss

Bitters
Jordan Guskind

Blue
Suzanne Saroff

Bodhi (Shepherd Mix)
Rachel Buntrock & Oleksandr Bilosorochka

Bodhi (Shiba Inu)
Yena Kim

Bowie
Sierra Yip-Bannicq

Brutus
Teresa Poon & Alvin Lim

Calvin
Janet

Clementine
Winnie Au & Florent Bariod

Collagio
Joseph

Cyder
Karen

Darcy
Frances Denny & Joshua Brau

Echo
Tessa & Jesse Samberg

Elaine
Ana Calderone & John Cassella

Finley
Elizabeth Weinstein & Andrew Benard

Frankie
Kate Itzkowitz & Andy Pagano

Gaia
Luca Seixas

George
Scott, Chris, Noah & Charlotte McKay

Gertie
Caroline Lange & Emily Bachman

Hank
Moumin Ghanem

Henry McGoober
Katie Young

Honeynut
Madison Kennedy & Mike Brewer

Izzy
Erika & Tom Devash

JoJo
Ken Hyde

Jolie
Delana

Kyrie
Ginny Johnson & Toren Kutnick

Leica
Jason & Annie Lu

Logo
Dalibor Porcic & Brian Vines

Lola
Cathy

Lumi
Sarah Schaaf & Stephen Bauer

Lux
Shannon Flammia

Milo
Erin Lee

Mishka
Zuzana Schaderova

Momo
Cindy Au & Callan Lamb

Nia
Lisa Smith

Odin
Charlotte & Vuk

Olive
Rui & Paul Gentile

Otis
Maddie Gay

Patch
Purvi Sheth

Penelope
Rich & Chantel Tong

Penn
Susan

Possum
Eleanor

Quille
Inke, Kayge, Skye, Zenne, Ohme & Deana Niosi

Quincy Fox
Katia Temkin

Remy
Liana Burns & Michael Gill

Rycher
A.J. Benson & Luke Gay

Ryder
Barbara

Sebastián "Sebi"
Michelle Mitre

Slayer
Jesse & Javier Zuniga

Tia
Marilyn

Toby
Brad Stein & Christophe Tedjasukmana

Tofu
Mara Navarro

Tsuki
Ona Janusiak-Beer & Orla Keating-Beer

Tyler
Linda

Waldo
Bernadett Treso & Gergely Treso

Zissou
Evi Manson

FOR THE DOGS

A portion of the proceeds from the sales of *Cone of Shame* will be donated to Animal Haven's Recovery Road Fund.

RESCUE ORGANIZATIONS

Some of the majestic dogs featured in this book were rescued from the following organizations:

Animal Rescue Fund of the Hamptons
arfhamptons.org

Badass Animal Rescue
badassanimalrescue.com

Best Friends Animal Society
bestfriends.org

Bideawee
bideawee.org

Korean K9 Rescue
koreank9rescue.org

Hearts & Bones Rescue
heartsandbonesrescue.org

MaPaw Siberian Husky Rescue
sibes.com

North Shore Animal League America
animalleague.org

PAW BVI
pawbvi.org

PupStarz Rescue
pupstarzrescue.org

Sato Project
thesatoproject.org

Small Bites Rescue
theneighborhoodvet.org/rescue

Tri-State Basset Hound Rescue
tristatebassets.org

OTHER RECOMMENDED RESCUES

All Dogs Matter
alldogsmatter.co.uk

Animal Haven
animalhaven.org

Barking Mad Dog Rescue
barkingmaddogrescue.co.uk

Battersea Dogs & Cats Home
battersea.org.uk

Blue Cross
bluecross.org.uk

Cookie's Rescue
cookiesrescue.com

Dogs Trust
dogstrust.org.uk

Humane Society London & Middlesex
hslm.ca

Indy Great Pyrenees Rescue
igpr.org

Mayhew
themayhew.org

Oldies Club
oldies.org.uk

Paws Rescue UK
pawsrescueuk.org

Social Tees Animal Rescue
socialteesnyc.org

Santa Monica Animal Shelter Foundation
smasf.org

Underdog International
theunderdog.org

Wild at Heart Foundation
wildatheartfoundation.org

Woodgreen Pets Charity
woodgreen.org.uk

ABOUT WINNIE AU

ABOUT MARIE-YAN MORVAN

Originally from Rockford, Illinois, Winnie Au now lives in New York City with her family and basset hound, Clementine. Winnie spends her time photographing people, food, interiors, and animals, and she dreams of someday having an army of long dogs. As an award-winning commercial photographer, Winnie has worked with clients such as Coca-Cola, Mastercard, American Express, the *New York Times*, *Elle Decor*, Refinery29, and *Vanity Fair UK*. Her photography has earned recognition and numerous awards, including from *American Photography*, the *Photo Annual*, and *Communication Arts*.

Winnie Au's photography portrays the exalted role pets play in our lives. She captures dogs in the same way that she photographs humans—to reflect the importance accorded dogs in the contemporary family.

Through her Cone of Shame series, Winnie transforms the post-surgery humiliation of pet dogs into something beautiful and majestic, turning the collars, designed by Marie-Yan Morvan, and the dogs within them into works of art. Her aim in creating these images is to highlight and raise funds for rescue dogs with urgent medical needs. The Cone of Shame series has exhibited across the US in The Photoville FENCE and most recently at Fotografiska Stockholm, Tallinn, and New York. She is the coauthor of *Dog-Friendly New York* and *Dog-Friendly London*. You can view more of her work at winniewow.com.

Born and raised in Paris, France, Marie-Yan lives and works in New York where she designs sets, props, environments, and costumes for clients such as Apple, Google, Spotify, Nike, Vogue, H&M, Nespresso, and Herman Miller.

Her work is often credited for its graphic sophistication, owing to the use of clean lines, strong shapes, and arresting color combinations.

The cones she designed for the Cone of Shame series are meant to respect and glorify the materials they're made of, while harmonizing with the look and disposition of the dogs wearing them. She approached each dog as if it were a living canvas, seeking out textures and props to build her cones that would feel like an organic part of each dog's body.

UNION SQUARE & CO.
SQUARE
& CO.

NEW YORK

UNION SQUARE & CO. and the distinctive Union Square
& Co. logo are trademarks of Sterling Publishing Co., Inc.

Union Square & Co., LLC, is a subsidiary
of Sterling Publishing Co., Inc.

ISBN 978-1-4549-4916-9
ISBN 978-1-4549-4917-6 (e-book)

For information about custom editions,
special sales, and premium purchases, please
contact specialsales@unionsquareandco.com.

Printed in the United States of America

2 4 6 8 10 9 7 5 3

unionsquareandco.com

All the dogs in this book, and in the entirety of the Cone
of Shame series, were supervised by professionals for
their comfort and welfare during their photoshoots.
The cones featured in *Cone of Shame* were crafted with
nontoxic materials and weighted properly for each dog's
comfort. The cones are purely decorative and should not
be duplicated for post-surgical use or other purposes.

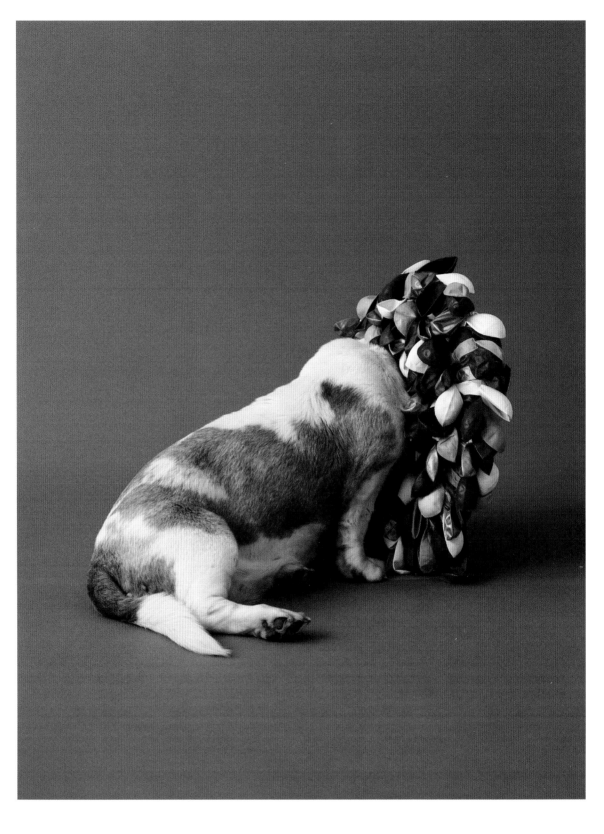